IMAGES
of America

TAYLOR

IMAGES
of America

TAYLOR

Irene K. Michna

ARCADIA
PUBLISHING

Published by Arcadia Publishing
Charleston, South Carolina

Printed in the United States of America

Library of Congress Control Number: 2011926190

For all general information, please contact Arcadia Publishing:
Telephone 843-853-2070
Fax 843-853-0044
E-mail sales@arcadiapublishing.com
For customer service and orders:
Toll-Free 1-888-313-2665

Visit us on the Internet at www.arcadiapublishing.com

We would like to dedicate this book to the early settlers in the Taylor area who established this town and the great history that has been passed down to us through the ages.

CONTENTS

ACKNOWLEDGMENTS

Special thanks go to the Taylor Public Library, Karen Ellis, City of Taylor; *Taylor Daily Press*; Williamson Museum; *Down Memory Lane*, compiled by Helga Patterson, Ruth Mantor, and Tassie Kennedy McCuk; Erwin Stauffer; Carrol and Carol Bachmayer; Gumi Gonzales; Jennifer Harris; Joanne Rummel; Jimmie and Carole Ann Preuss; Bill and Dixie Rhoades; Helen Kinlow, Dean Threadgill, Edward Wolbrueck, Calvin and Anna Jayroe; Joanne Bachmayer; Rob Aanstoos; and Dorthy and David Weber. Special thanks go to Deby Lannen, Claire Maxwell, Joanne Rummel, Carole Ann Preuss, John Wehby, and Jean Johnson for proofreading and support.

Most the images appear courtesy of the Taylor Public Library. Karen Ellis compiled and labeled the historical images.

I would like to extend a very special thank-you to all the early settlers in the Taylor area that first settled this town and gave us the history to write about.

INTRODUCTION

Once upon a time, as all good stories begin, Taylor was a small country town, typical of other countless small towns all over the nation, and, like them, the place where families were formed and where children grew up amid scenes and events that eventually became their memories. Taylor is one of those towns. Taylor is located in southeastern Williamson County, Texas, at the intersection of the Missouri Pacific and the Missouri, Kansas & Texas (MKT or Katy) railway and State Highway 95 and US Highway 79. At the anticipation of the arrival of the International–Great Northern Railroad (I&GN) in 1876, the Texas Land Company auctioned off lots. Taylor was first called Taylorsville, but in 1892 the name Taylor, after railroad official Edward Moses Taylor, became official. The first settlers were from Czechoslovakia, Germany, Austria, and England. They were the ones to help build Taylor, which became a shipping point for cattle, grain, and cotton.

In 1879, a fire destroyed 29 out of the town's 32 businesses. In 1882, the Taylor, Bastrop, and Houston Railway reached Taylor. Machine shops and a roundhouse serviced both rail lines. The town was incorporated in 1882 with a five-member board of commissioners. The public school system was established in 1883, and in 1890 there were two banks, a cotton compress, several newspapers, an electric company, and a water line from the San Gabriel River. In the early 20th century, an artesian well was drilled, city hall was constructed, and a hospital was built. There were 7,875 residents and 225 businesses in 1940. Taylor proclaimed itself "the largest inland cotton market in the world." By 1983, there were about 22 manufacturers and processors. Maize, wheat, and cattle joined the cotton production. There was also a radio station, daily newspaper, Southwestern Bell Telephone, Texas Power and Light Company, Lone Star Gar, and a radio station that served the residents of Taylor.

Taylor has sent a governor and a number of state representatives to Austin. Taylor now has a hospital, clinic, nursing home, assisted living quarters, and an ambulance and fire service. The State Department of Highways and Public Transportation, the National Guard, and the Child Development and Neighborhood Center all have offices in here. Taylor is home to the Moody Museum, Murphy Park with the Liberty Gardens, tennis courts, a pavilion, putt-putt golf, a lake, bandstand, basketball courts, playground, public swimming pool, and the Lou Belle Harris Gazebo. There is also the Bull Branch Park, Fannie Robinson Park, Rodeo Arena, and a new East Williamson County Regional Park with baseball, softball, football, soccer, and a lake.

There are still citizens of Taylor who remember things like summer evenings when the grown-ups sat in the front yard while the children played run-sheep-run and chased fireflies. They remember the impassable muddy streets after a heavy rain and waiting all week for the Saturday movie matinee.

What a great town to grow up in!

One

EARLY YEARS

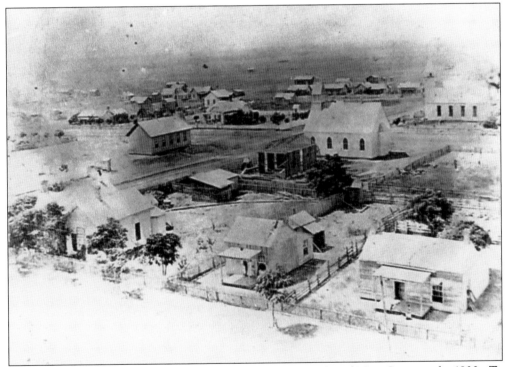

This image was taken from the wooden water tower at Seventh and Main Street in the 1800s. To the extreme left in front is Dr. Black's home, which later became the Threadgill home. The home was located on the corner of Sixth and Main Streets. T.W. Mares later converted this home into a mansion, and it eventually became Condra Funeral Home. The building with five windows, to the left in the center, was Professor McMurray's school and Sunday school. Looking north on Main Street are the Presbyterian Church and the Christian Church.

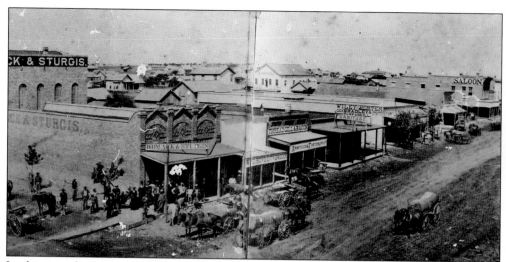

Looking north on Main and Second Streets, one can see the many businesses lining the streets in 1883. Womack & Sturgis was one of the first businesses in Taylor. Also in the early days were W.D. Boyd Grocery, Threadgill & Bacon, Wiley Porter Furniture, and a saloon to the north end of the street.

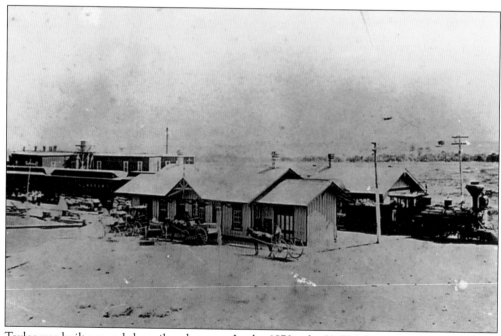

Taylor was built around the railroad system. In the 1870s, the I&GN depot was also used as the Union (now Union Pacific) station. The Katy would circle and come in at the east end of the building. As indicated by its large stack, this engine was a wood burner. Wire mesh was over the opening to keep down the sparks.

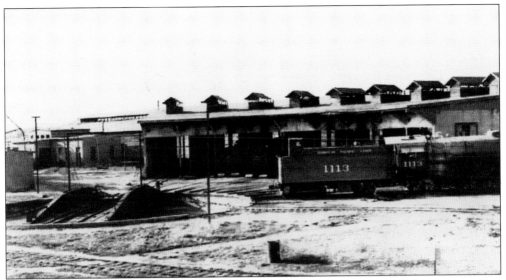

This 1901 picture shows several railroad engines that are in the repair shop. The steam engines in the area would come to Taylor to have any and all repairs done. The repair shop was called the Round House. There is a round pit with tracks in the middle, which could be turned to whichever holding space was available. Engines returning to the main track would use the round pit in the same way.

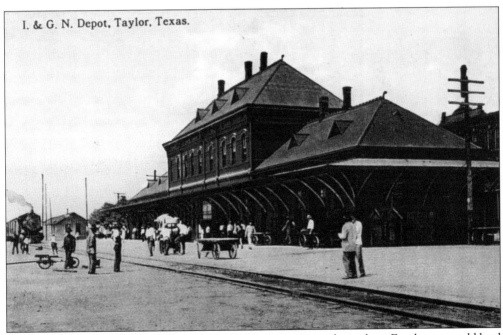

The I&GN depot in 1911, located on East First Street, was a very busy place. Employees would load the suitcases on the platform dolly and then load the trains. Many people gathered to welcome loved ones home or to see them off. The large depot was demolished, and a smaller depot has been built there.

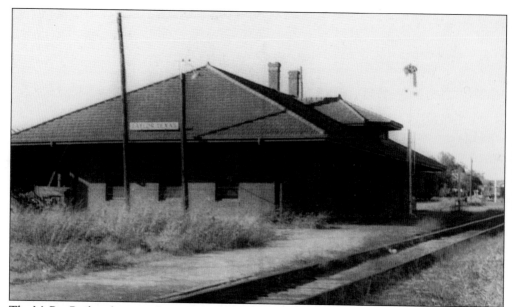

The MoPac Railroad station, located in east Taylor, was not as busy as the I&GN station. Travelers to Houston would use this depot to catch the train. The station was demolished many years ago. (Courtesy of Claire Maxwell.)

Shown in the 1880s, Taylor's first city hall and fire station was located near the present city hall. City hall's offices were upstairs, and located below was the fire station. Some form of firefighting equipment and personnel has existed in Taylor since it was founded in 1876.

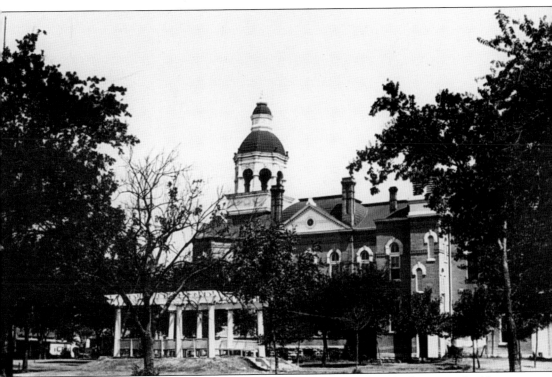

This building was built in 1905 and was home to Taylor City Hall until 1935, when a new building was built in its place. This 1920 picture shows a beautiful city hall and gazebo, just south of the building. Named Heritage Square, this area has been the location of many concerts and other types of entertainment throughout the years.

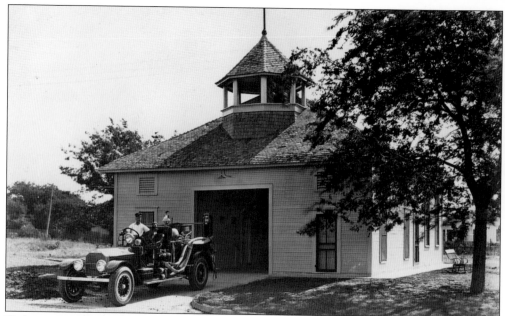

Taylor acquired a second fire station on Victoria Street in the early 1920s on land donated from the Burns family. This station was remodeled in the 1950s with living quarters and was called the West End Fire Station. A.A. Gus Reno is pictured on the fire truck in front of the West End Fire Station.

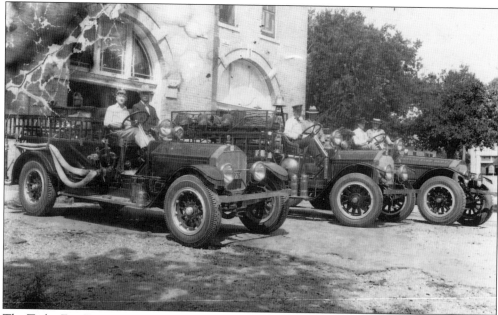

The Taylor Fire Department organized in 1932. The fire station bays were located on the east side of the city hall building. The first firehouse started service with the department in 1883 and was sold in 1957 to the Patterson family, who donated it to the Methodist church, which still uses it today. This station was replaced with the beautiful, brick City Hall Opera House in 1905. The fire department had the entire east side for its three bays, which contained the fire wagons and horse stalls; the current South Station replaced it in 1935.

Two

BUSINESSES

In the early 1800s, Taylor was a very busy town with new businesses moving in all the time. These gentlemen helped deliver to the citizens. Standing beside his ice wagon, H.A Bryan, the father of Doris Roznovak, delivered ice to the residents in town. Since there were only ice boxes in the homes, this was essential. (Courtesy of Doris Roznovak.)

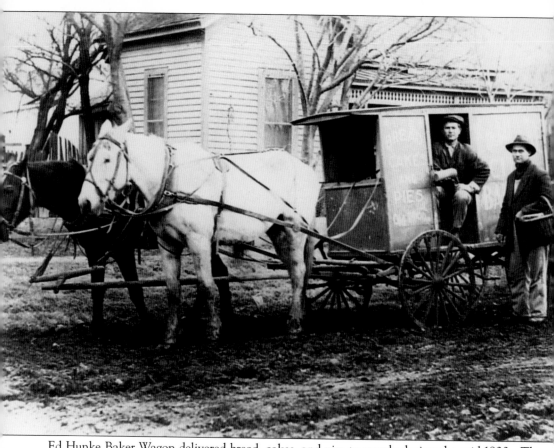

Ed Hunke Baker Wagon delivered bread, cakes, and pies to people during the mid-1800s. The gentleman standing beside the wagon looks like he has already purchased his baked goods.

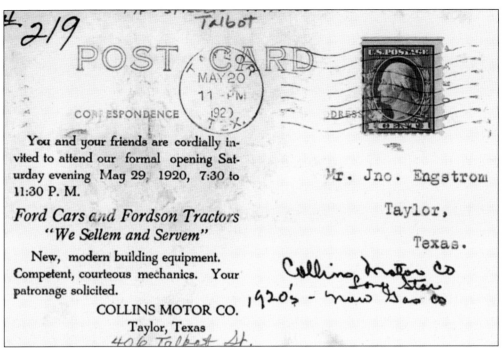

In 1920, Collins Motor Company held its formal opening on Saturday evening, May 29. The business was located at 406 Talbot Street.

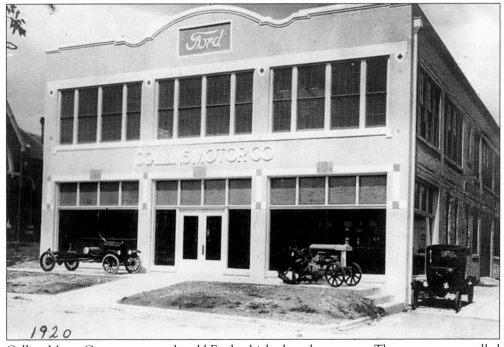

Collins Motor Company not only sold Ford vehicles but also tractors. The tractors were called Fordson Tractors. One of the company's advertisements stated that employees would not only sell vehicles but also service them.

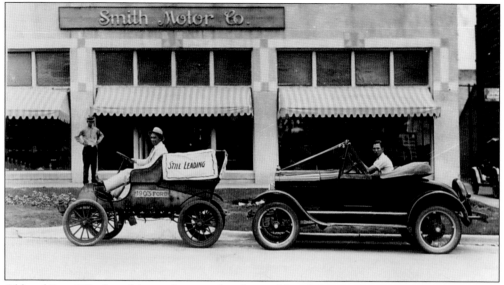

Old and "new" Ford models are showcased in front of Smith Motor Co.

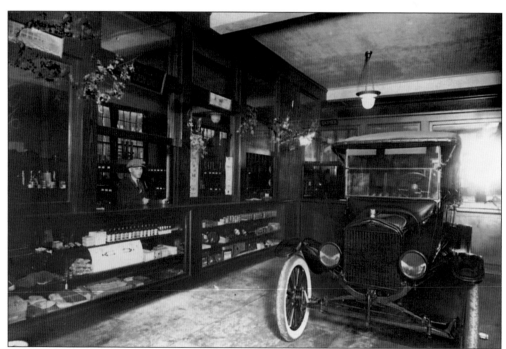

Shown inside Collins Motor Company is an early 1920s Ford Model T car. Behind the counter is Herbert Patterson ready to help with all of the items needed to keep one's car tuned up. In later years, the building was used by Lone Star Gas Company.

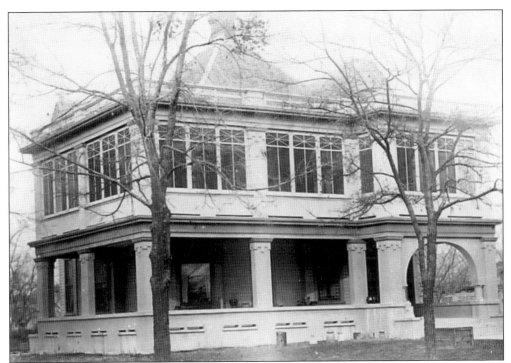

F.L. Welch's home at 503 Talbot Street was built around 1900. Welch was a banker with the First National Bank. This home was a real showplace that everyone admired.

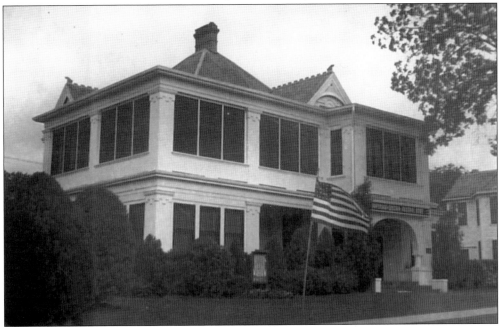

In 1910, the Welch home was converted to the Fontaine Forwood Funeral Home. In the late 1930s, Ray Condra joined the organization and the funeral home became Forwood-Condra Funeral Home. The name was later changed to Condra Funeral Home. The business has changed ownership but remains Condra Funeral Home. Original furniture keeps the home looking as it was originally.

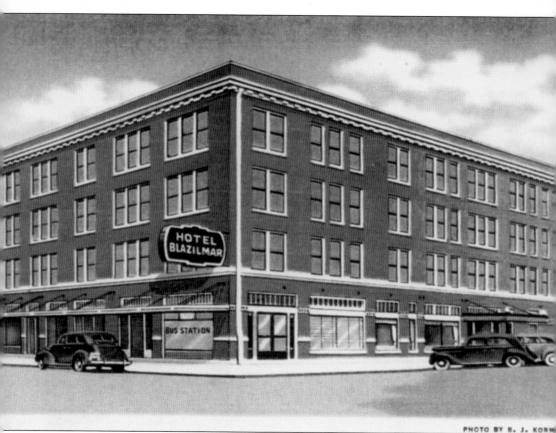

The historic Hotel Blazimar was named after three different gentlemen: Howard Bland, A.J. Zizinia, and T.W. Mares. The impressive four-story hotel was fireproof and had steam heat and ceiling fans in each of its 90 rooms. A ballroom on the second floor was used for social gatherings. The hotel also served as the Greyhound Bus station. In 1920, the St. Louis Browns wintered in Taylor. They roomed at the hotel and practiced on what is now Memorial Football Field. A fond memory of the kitchen at the hotel was the great chili that was served. The Blazimar kitchen was the only place one could get a meal after 9:00 p.m. The building is still at the corner of Porter and First Streets but is no longer in use; however, it is still an impressive sight.

In 1907, James Arthur Athas came to Taylor. He was a friendly, jovial Greek who everyone loved. His uncle had taught him the art of making candy, and thus, he was nicknamed "Candy Jim." They worked together in the Waco area before Candy Jim moved to Taylor.

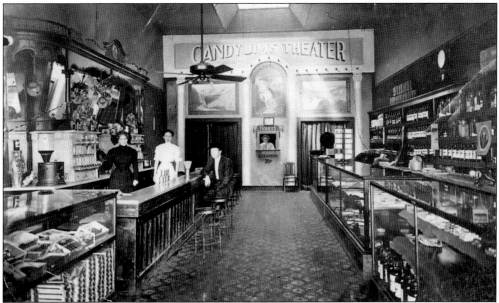

Candy Jim owned a theater called Candy Jim's Theater. A mouthwatering fragrance drifted out the doors of his place on Main Street. Eventually, he sold the theater and moved the candy store next door to continue making those wonderful sweets. The most popular was sauerkraut candy.

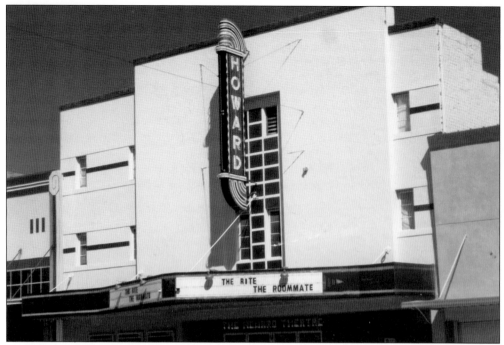

The Howard Theatre in the early years was located on the east side of Main Street where Taylor Sporting Goods store is now located. The Rita Theater was in the building that the Howard Theatre is in today. When the Rita closed, the Howard moved across the street to its current location.

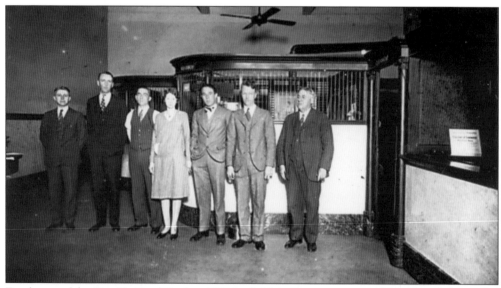

Employees of the City National Bank at 210 North Main Street are pictured here from left to right: August Letterman, unidentified, Roy Camblin, unidentified, John M Griffith, Tom Holmstrom, and John H. Griffith. The bank is now located at 212 North Main Street.

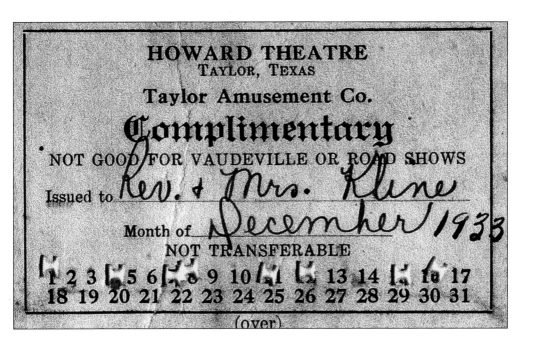

Under the name of Taylor Amusement Company, complimentary tickets were available at the Howard Theatre. This was issued to "Reverend and Mrs. Kline" for the month of December 1933. (Courtesy of Dean Threadgill.)

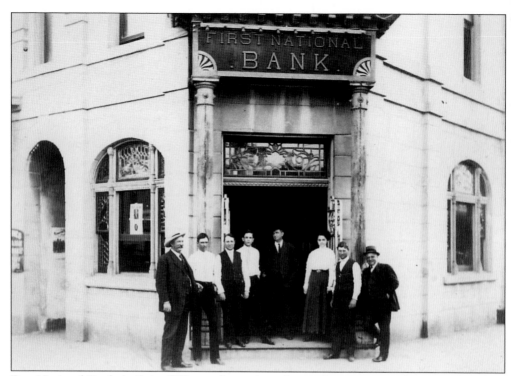

First National Bank, built in 1883, was located on the southwest corner of Main and Second Streets. Employees at that time were F.A. Allison, C.W. Lundell, Frances H. Welch, Jess Womack, Robert J. Eckhardt, Ruby Langford, Thompson Hague, and F.L. Welch.

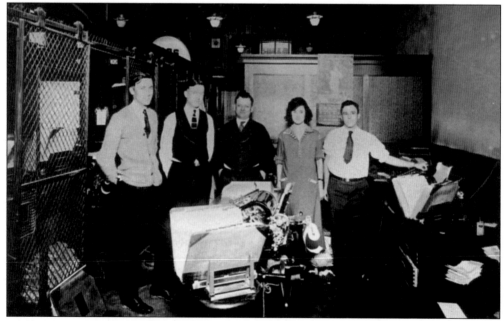

Taylor National Bank in 1924 was located on the Northeast corner of Main and Second Street. Employees at that time were H. F. Weghorst, Dave Thomson, Arthur E. Ake, Grace Johnson and Virgil Patterson. In later years the two banks merged and became First Taylor National Bank.

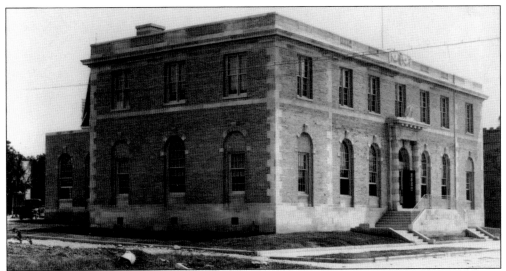

The first post office established in this community opened in 1876 under the name Taylorville. In 1882, when the city was incorporated, the name changed to Taylor. The post office was housed in a number of locations until this structure was built in 1929–1930. A finely crafted example of the Classical Revival style that characterized Federal projects of the 1920s, the building features six round-arched windows on the ground floor, a balustrade and parapet with garland panel on the second floor, an elaborate entry portico, stone columns, and a classical entablature.

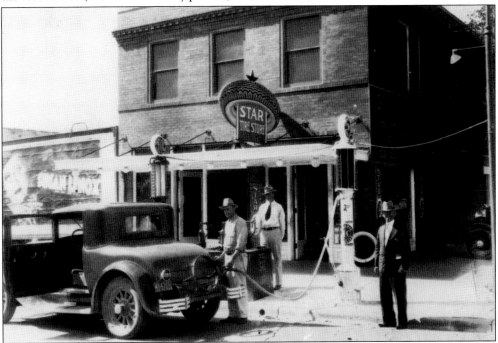

In 1931, this was where people would buy gas for their automobiles. One could also buy tires, oil, and other items for a vehicle. The gas tanks are a little different today. The square container, located between the two gentlemen, was used to hold the oil. The pump is also visible. On the left side of the store is an advertisement for the currently showing movie, *Susan Lenox, Her Fall and Rise*, staring Greta Garbo and Clark Gable.

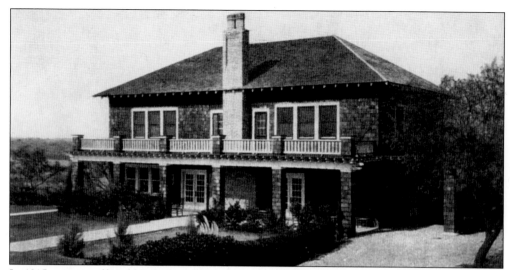

In 1915, a group of local bankers purchased 60 acres on Washington Heights overlooking Taylor. They noticed the open plains and gently rolling hills looked similar to the historic courses in Scotland. The golf course is the 14th oldest in the state. In 1924, Taylor Country Club was built on the same property. For 64 years, the course was a semiprivate club with emphasis on the beautiful clubhouse, pool, and famous food. In the 1980s, a group of local businessman purchased the golf course from the Taylor Country Club. In 2006, local investor shareholders purchased the Taylor Country Club. They have spared no expense to remodel the club to its former beauty and prestige. The club will soon be open for facility rentals and special dining events. (Courtesy of Claire Maxwell.)

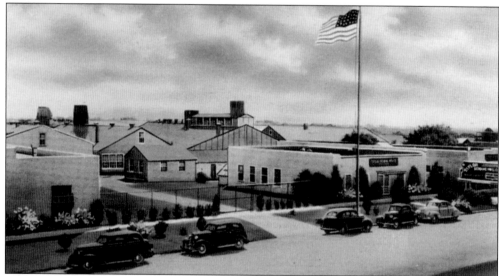

Taylor Bedding is the world's largest bedding company. D.R. Forwood and his family founded the business in the 1900s. They found a way to use the cotton that was produced on the family plantation. In 1914, they acquired the location where the company still manufactures today on West Second Street. During World War II, this company furnished the mattresses and pillows that were used by American troops. Legend is that a young Taylor man was in the service and when he saw the tag on his pillow that read "Made in Taylor, Texas," he said he then felt closer to home.

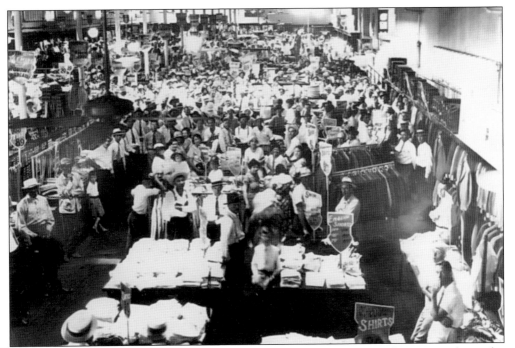

T.W. Mares Department Store was always such a busy store. In 1920, the picture shows the customers standing arm to arm. The store supplied clothing needs, young and old. The store was located at 108 Third Street.

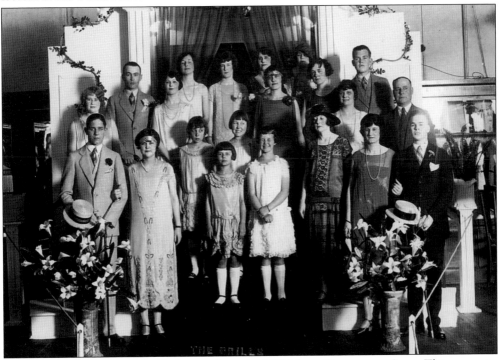

One of the first style shows in Taylor was from the T.W. Mares Department Store. This was quite a show in the early years.

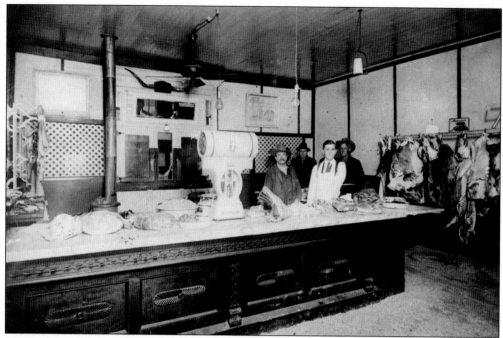

Martin Matteck owned a meat market in 1915 that was located on South Main Street. Look at all of the meat on the counter and hanging. Employees also smoked sausage at the market. (Courtesy of Rob Aanstoos.)

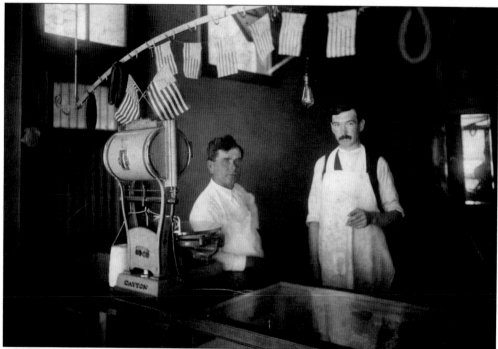

At 105 East Third Street was a butcher shop that was owned by partners Emmit Bohumil Sefcak and Joe Manjasek. One can see the sausage hanging from hoops along with flags. The shop later housed several restaurants. (Courtesy of Dixie Rhoades.)

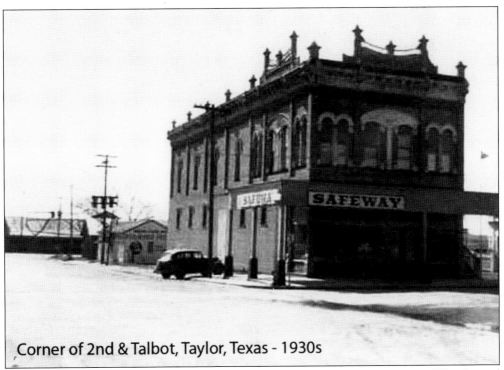

Corner of 2nd & Talbot, Taylor, Texas - 1930s

The Safeway Building was located on the corner of Second and Talbot Streets at 201 West Second Street. The store was built in the 1930s. In later years, it was Taylor Paint and Hardware Store. The building burned but was bought by Taylor Conservation and Heritage Society. The building was restored and now houses Taylor Art Signs.

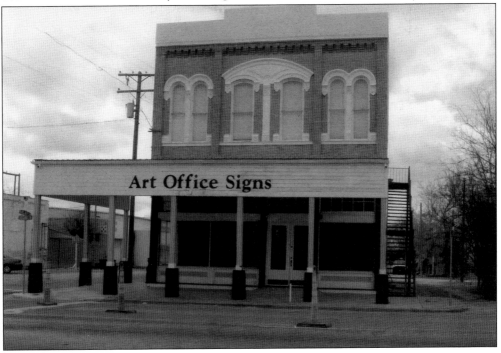

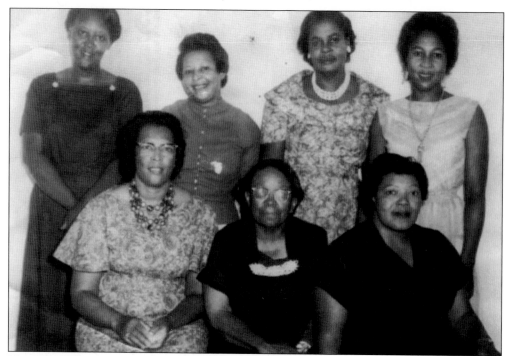

There were many beauticians in Taylor. Those beauticians pictured are, from left to right, (first row) Ella Harrison Johnson, unidentified, and Wilma D. Clark; (second row) Fannie Ann Lloyd, Catherine Fields, Viola Marshall (Jennifer Harris's mother), and Hazel Loyd Boyd. (Courtesy of Jennifer Harris.)

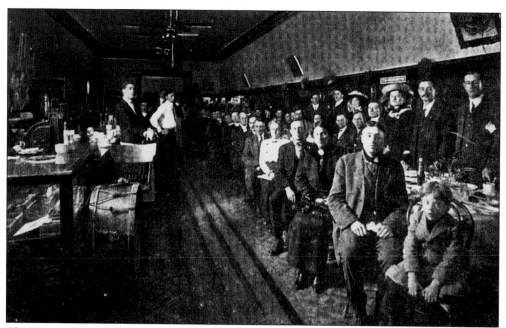

The Metropolitan Café was one of the more popular places to eat, as one can see with the room completely full of well-dressed patrons.

Sometime during the earlier years, these mules worked for the City of Taylor to complete jobs that people could not. Also pictured is a gentleman that cared for the mules.

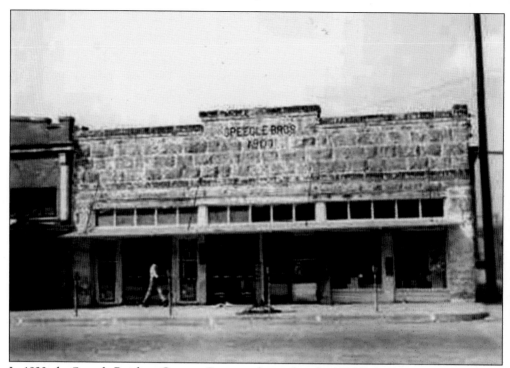

In 1920, the Speegle Brothers Grocery Store was located in the 100 block of Main Street and was one of the busiest grocery stores in town. On top of the building, it states, "Speegle Bros. 1903." This building is still standing with the name very visible on the top.

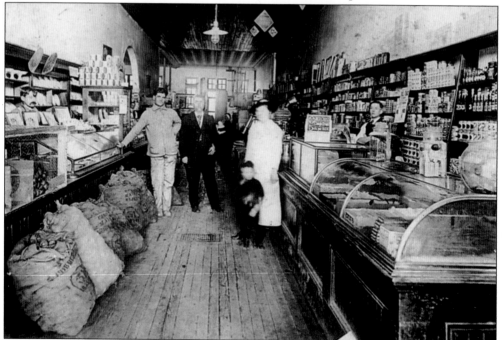

In 1910, Stasney and Holub opened a grocery store at 310 North Main Street. The store was small but had plenty of supplies and faithful customers.

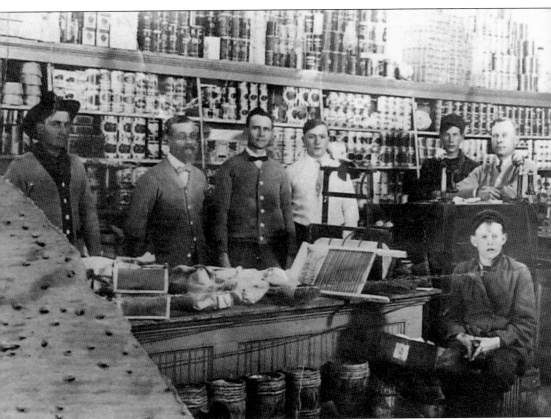

Another grocery store in Taylor was the Wolters-Rhode Grocery, located in the 100 block of East Third Street. The store was opened in 1910. This was at a time in the history of Taylor that there were many residents, meaning there was a great need for additional grocery stores.

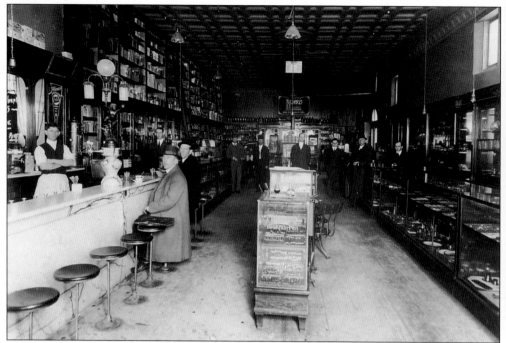

The Dailet Drugstore was located at 217 North Main Street. The store had a soda counter that was very popular. They not only sold medicine but also other items that families might need. The medicine bottles that were used were so unique in color and shape.

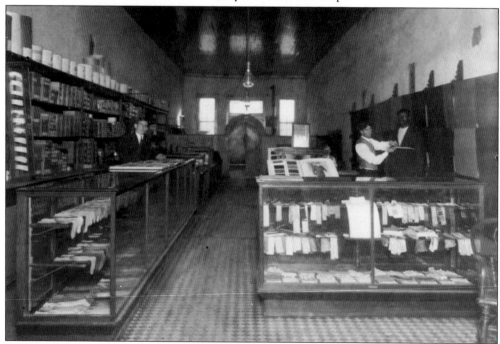

T.J. Duffy's Gents Store sold suits and all the apparel that a gentleman might need. As one will notice, they are measuring an individual for a new suit. Duffy also had a drugstore on South Main. (Courtesy of Rob Aanstoos.)

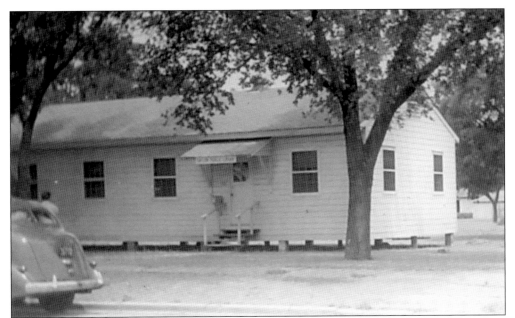

In 1948, the library moved from Taylor City Hall to the east half of the Girl Scout Building at Eighth and Fowzer Streets on the Taylor School grounds. In 1956, the library moved to a building on the school's property at Ninth and Hackberry Streets. In 1960, the library moved to the building at 801 Vance Street. The Library Board of Trustees in 1960 consisted of T.H. Johnson, Mrs. Ralph Johns, F.E. Wilks, Mrs. Wilson Fox, Mrs. Arthur Ake, Mrs. J. Frank Smith, and Mrs. L.D. Hammack. At the dedication service for the library, Dan Moody was the speaker.

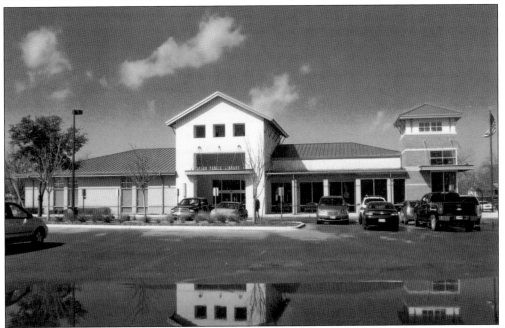

In 2002, the library closed due to water damage, mold, and structural damage. It was first moved to the old Taylor Middle School for a couple of months and then to Taylor City Hall. The new Taylor Public Library, located 801 Vance Street, was opened on March 31, 2007.

35

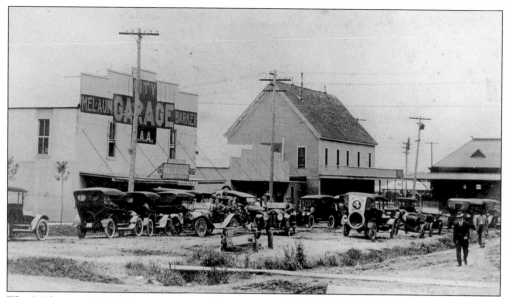

The Melaun and Barker City Garage was a real popular place that locals would bring their automobiles. Note there is a sign stating that gasoline is only 12¢ a gallon. The garage also had the ability to vulcanize tires and tubes. The railroad station sits to the right of the garage.

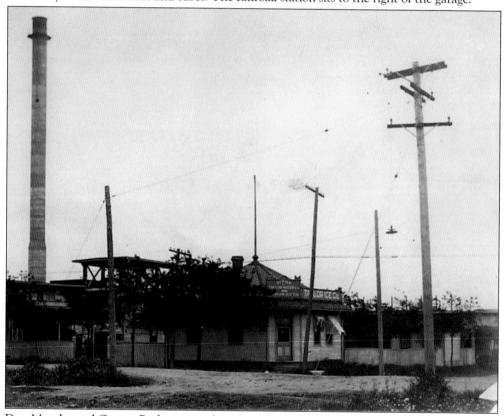

Dan Murphy and George Burkitt started waterworks and Taylor Ice Company, located on East First Street in Taylor, in 1882–1883.

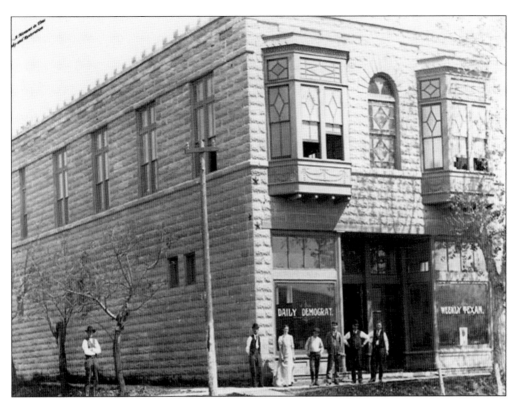

This building is located on the corner of Fourth and Talbot Streets. In the early years, the *Daily Democrat* and the *Weekly Texas* newspapers used the building.

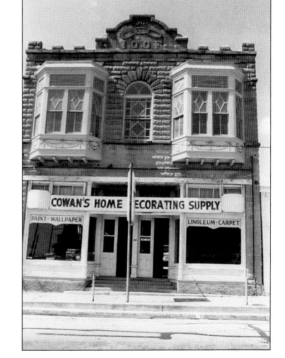

Cowan Home Decorating was the place where the people of Taylor could buy their paint, wallpaper, linoleum, or carpet. The building is now occupied by the restaurant, Mimosa. On the top of the building, the date 1907 indicates when the Independent Order of the Odd Fellows (IOOF), a fraternal organization, built it.

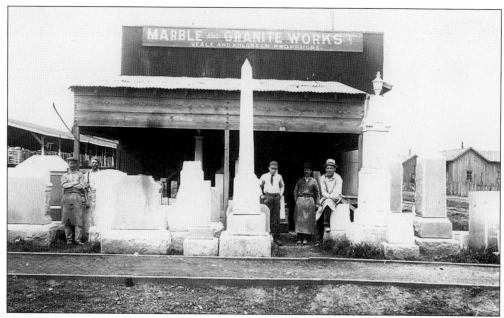

Hugh Beale and August Ahlgreen owned the Marble and Granite Works. The shop was located on East Walnut Street and serviced all of the residents of Taylor with its monuments and tombstones. (Courtesy of Carol Ann Preuss.)

Bob Sims Sign Shop was located between Tenth and Eleventh Streets on the east side of Main Street. Many remember the elephant that on top of the building. The elephant remains on the building. With Bob Sims in the middle were a couple of friends. On the left is Roland Sefcak, father of Dixie Rhoades, local artist, and on the right is Doogie Cox.

Three

EARLY SETTLERS

The Moody family was one of the earliest to settle in Taylor. Daniel James Sr. and Nannie Elizabeth Robertson Moody had a son, Daniel Moody Jr., on June 1, 1893, who later became the youngest governor ever to be elected in Texas. He graduated from Taylor High School and then attended the University of Texas, taking law courses. He was admitted to the bar in 1914, and his first job was in Taylor with the Harris Melasky law firm. During World War I, Daniel Jr. served as second lieutenant and captain in the Texas National Guard and second lieutenant in the US Army. He also served as the county attorney of Williamson County, district attorney, and then attorney general of Texas. He defeated Ma Ferguson for the position of governor of Texas. Daniel Jr. was also the first attorney to ever win a legal battle against the Ku Klux Klan. A reenactment of the Ku Klux Klan trial is held in Georgetown. (Courtesy of Susan Komandosky and the Moody Museum.)

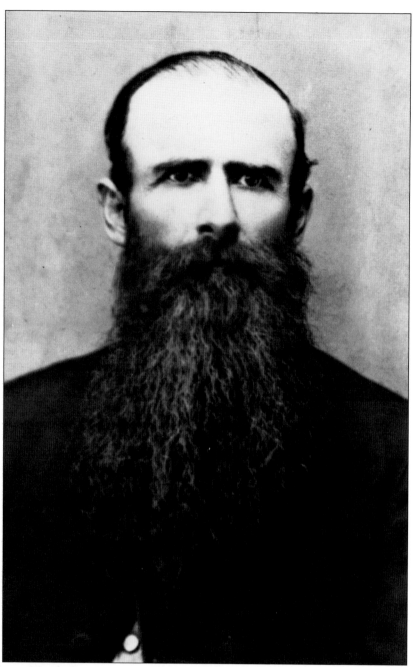

Daniel James Moody Sr. was commonly referred to as "Judge Dan'l," because he was the justice of the peace. Moody Sr. came to Taylor as a railroad agent to sell lots and help start the town in 1876. He was Taylor's first mayor, helped start the Taylor public school system, and served as chairman of the school board. In 1890, he married math teacher Nancy Elizabeth Robertson. He enlarged the home that Nancy Moody's family built. Judge Moody lost all of his money when the business in which he had invested went bankrupt. He then started a dairy at his home, and the couple rented rooms to teachers and travelers to make money. Judge Dan'l died in 1910, the same year Dan Jr. graduated from high school.

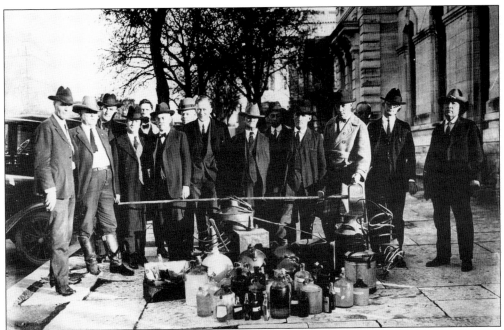

Dan Moody Jr. (center) is pictured with a group that includes T. Fox, W.H. Scott, O.P. Bonner, Jim McCoy, Raymond Brooks, W.D. Miller, S.A. Philquist, James R. Hamilton, Mr. Priest, Mr. Meredith, and several unidentified men at the state capital in Austin, Texas, on December 14, 1923. The group is pictured with "illegal liquor dumped into storm sewer."

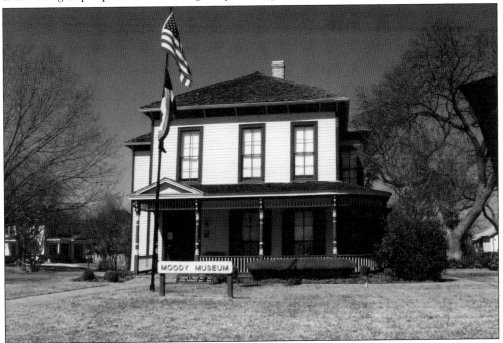

The Moody Museum is the original home of the Dan Moody family and is located at 114 West Ninth Street. The Museum honors both Dan Moody Jr. and Sr. They were both very instrumental in so many aspects of the growth of Taylor.

Mary Moody was sister of the governor of Texas and the daughter to Dan Moody Sr. She was a very capable businesswoman of Taylor, having been born and raised here. Her love of music and her friends' love of music prompted her to start the Taylor Music Club.

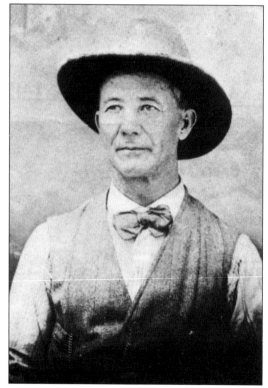

Elijah Lambertson, or "Hot" as he was affectionately called by everyone, was born May 7, 1870. He was a familiar figure in town for many years and was remembered for the delectable product that he sold, the most delicious hot tamales ever. His familiar cry was, "Hot tamales, hot tamales, get 'em while they're hot." They sold for anywhere from 10, 15, or 25¢ a dozen. He always gave extras. He passed away in 1936 and was never married. His sister Nannie Powers lived next-door to him on Buttermilk Hill. Nannie's daughter Maude Sadie Childress had four daughters: Doris Roznovak, Dorothy Wauke, Ruth Fledge, and Aileen Roderick. They were a great niece of "Hot." He was surely one of Taylor's most colorful characters and was affectionately remembered by early citizens. (Courtesy of Doris Roznovak)

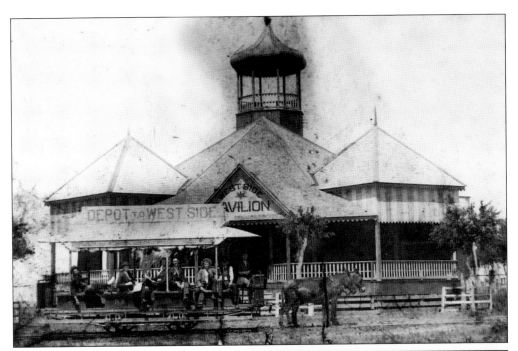

The Doak Pavilion site is located at the end of Seventh and Sloan Streets. Dr. A.V. Doak, an early settler and civic leader, built the pavilion in 1891. The pavilion sat at the end of the streetcar line, which was operated with mule-drawn cars. The pavilion was also used for plays, dances, and other amusements. The pavilion held crowds of 1,000. In 1900, the pavilion was torn down, and the Klein home was built on this lot.

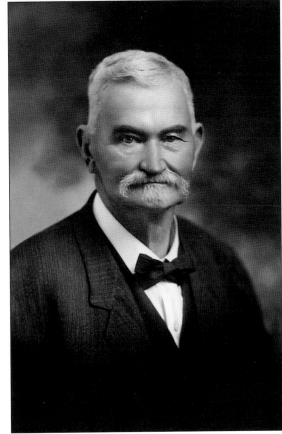

John Kritser was an early Taylor pioneer, wagon master, cattle driver, and Taylor city marshal. He was what you would call a real Texan.

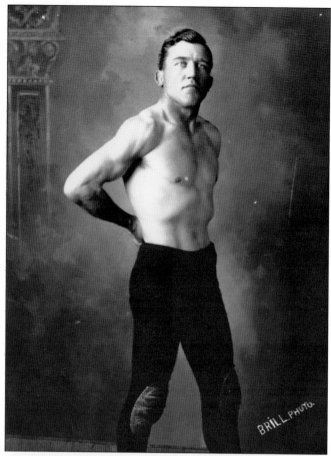

Elmer "Pet" Brown, was born September 12, 1888, near Brown Gin on Highway 95 South. His grandparents on both sides came to Texas before the Civil War. As the World Middle Champion Wrestler, he was a celebrity, but more than that, he was every inch a man. People would often say that he was the finest man they had ever known. He started wrestling with his brother Frank Brown. Taylorite Jim McLaughlin returned home from the Army as a champion boxer who had also done some wrestling. He and Pet hit it off right away, and Jim became Pet's first trainer. Unfortunately, Pet was shot and killed at his construction camp near Cisco, Texas.

Martha "Mattie" Sproul never graduated from high school and never received any formal training in music. This did not deter her from learning music, and the "Brain Fever" (meningitis or encephalitis) she had endured as a child left no damage. Whenever there was a musical performance, she would be there to accompany them. One of her granddaughters, Kathleen (Mrs. Marvin Brinkmeyer), also played the piano by ear, and Kathleen's daughter played and taught lessons. Kathleen's daughter Melissa Cuebas lives in Taylor and says she did not inherit this talent.

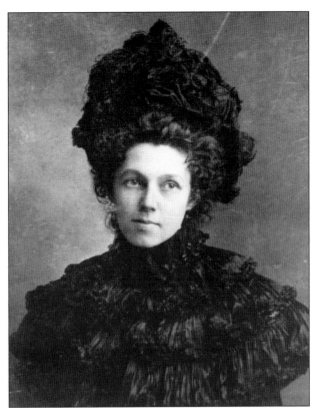

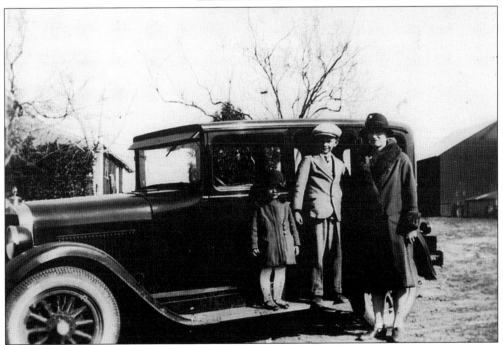

Augusta Mager Beyer, her son Hugo Beyer and daughter Elsie Beyer Bachmayer posed for this picture in 1929. (Courtesy of Carrol and Carol Bachmayer.)

G.M. Kuykendall (center) is shown with daughter Ruth and a friend. Trail boss of several trail drives to leave the Taylor area, he led the last cattle drive to leave Williamson County on the way to Nebraska. He made five trips up the Old Chisholm Trail and was boss on the largest herd of cattle ever driven up the trail from Texas. There were 3,000 plus head of cattle. Members of the family recall that he and Alf Meinelle, one of his closest friends of Hutto, spent one winter in dugouts in Kansas when all of the horses froze to death. He also drove herds to Chicago and Nebraska. He was also sitting on his horse when the first lot in Taylor was sold. G.M. Kuykendall has a granddaughter, Joanne Arledge Rummel, and a great-granddaughter, Irene K. Michna, and several great-great and great-great-great grandchildren living in the Taylor area. (Courtesy of Joanne Rummel.)

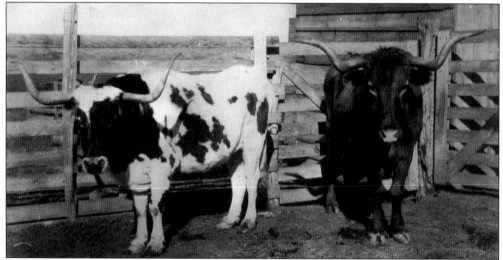

Here are two of the longhorn steers that were a part of the drive. These steers represented the many longhorns that were led up the trail.

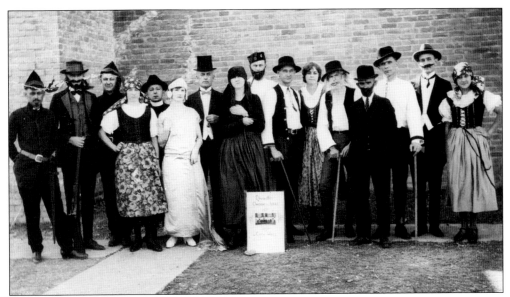

Members of the Catholic Czech Little Theater Group in the 1920s included Ondras A Junas, Joe Mikolaj, Ludnila Mikolajova, Arnost Kachlin, Rainmund Veselka, Bertha Hrnchrova, Adolf Jakubik, Joseph Eineigl, Zofie Spanova, Antonin Stiborik, Bozena Cernoskova, Javoslav Mares, Joseph Jarolim, Rud Jasek, Rudolf Jasek, Editha Maresova, and Arnost Kachlin. Tickets for shows were 50¢ for adults and 35¢ for children. (Courtesy of Dorothy Weber.)

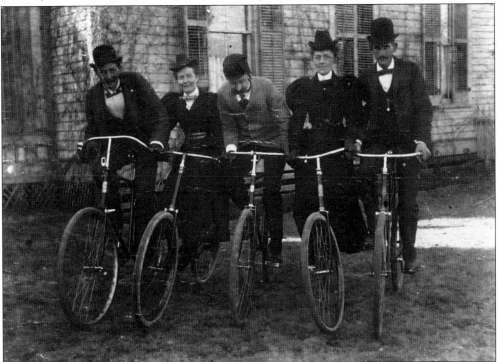

First five bicyclists of Taylor in 1900 are pictured in the front yard of the Sturgis home at the corner of Fourth and Burkett Streets. Pictured from left to right are J.W. Council, Mrs. J.P. Sturgis, F.E. Carradine Sr., Mrs. Byron Heard, and John Brunner.

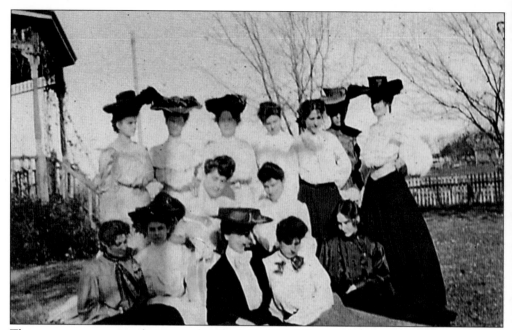

These young women were known as the "Bachelor Girls." Pictured from left to right are (first row) Verei McFadin, Olga Womack, Julie Struve, Vivian Henderson, and Laura Kritzer; (second row) Mabel Pumphrey and unidentified; (third row) Lizzie Pumphrey, Edith Coupes, Marie Burns, Ella Struve, Bess Brunnell, Della Black, and unidentified.

Massive amounts of rain in 1921 caused extensive flooding. Earthquake tremors were felt at 5:45 a.m. on August 16, 1931. Herbert N. Patterson was a cooperative weather observer from 1933 until 1973. The most snow on record occurred on January 13 and 14, 1944. The coldest weather on record was minus five degrees on January 31, 1949. The hottest day was recorded at 112 degrees on July 26, 1954. The earliest killing frost was on October 30, 1957. The latest killing frost occurred April 5, 1920. The aurora borealis appeared, probably more than once, but certainly most beautifully on April 27, 1956. Normal rainfall is around 35.47 inches.

Julius and Anna Kroschewsky came to America between 1871 and 1873. They arrived in the Taylor area in 1878. They had several businesses in and around Taylor, including a hotel, dairy, and gin, and owned 800 acres northwest of Taylor. (Courtesy Edward Wolbrueck Jr.)

Howard Jenkins was a surveyor for the Missouri, Kansas & Texas Railroad. He surveyed and planned for the line through Circleville to meet with the I&GN line in Taylor in 1882.

These young men became friends after the loss of their hearing during World War I and attended a lip-reading school in Dallas. Pictured from left to right are Bernard Babiak, Rudolph Beyer from Coupland, and Fred Jaggi. (Courtesy of Carroll and Carol Bachmayer.)

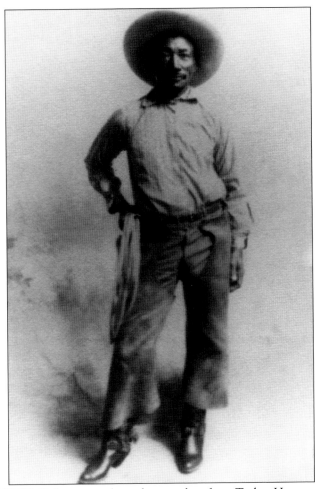

William ("Will," "Bill") Pickett was a legendary cowboy from Taylor. He was born December 5, 1870, in the Jenks-Branch community. His parents, Thomas Jefferson and Mary Virginia Elizabeth (Gilbert) Pickett were both former slaves. Pickett was of African, white, and Cherokee Indian ancestry. Pickett had two cousins who were trail-driving horsemen. Bill loved to listen to them tell the stories about buffalo stampedes, roping steer, and breaking ponies. He wanted to learn these skills. One day while Bill was on his way home from school, he saw a bulldog hold a cow's lower lip with its teeth. He thought this was something he wanted to try. One day, there were some cowboys branding calf's and were having a rough time. Bill asked if he could help, and he bit into the calf's lip and helped the calf down while the cowboys branded the calf. This is how he invented this unique way of subduing cattle called bulldogging, also known as steer wrestling. He finished school through the fifth grade. At the age of 15, he started working as a cowhand on many ranches. He worked at a ranch east of Taylor that was owned by the governor of Nevada, and the foreman was G.M. Kuykendall. On this ranch is where he invented the art of bulldogging. He would ride his horse hard, spring from his horse, and wrestle the steer to the ground. It is estimated that he bulldogged about 5,000 animals. Pickett married Maggie Williams on December 2, 1890, and had nine children. He lived with his family in Taylor, where he was a member of the National Guard and a deacon of the Taylor Baptist Church. In 1970, he was the first black man inducted into the National Rodeo Cowboy Hall of Fame and also in the Pro Rodeo Hall of Fame and Museum of the American Cowboy in Colorado. It was said that Pickett was the greatest sweat-and-dirt cowhand that ever lived—bar none.

Shown are a number of members of the Sons of Herman Lodge on May 9, 1903. The organization was a very popular lodge in Taylor. It held yearly May fêtes, which were well attended. The Old Austin Highway was renamed Herman Sons Road, since it ran in front of the lodge.

In her home on Seventh Street, Mary Doak, the wife of Dr. Doak, is shown visiting with Herbert Patterson and his son John.

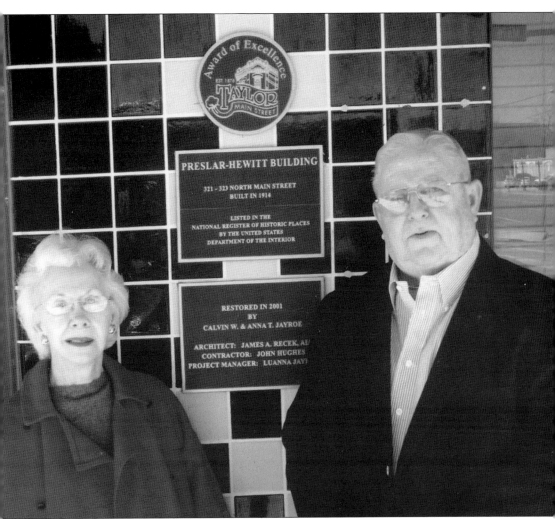

Calvin and Anna Jayroe are the owners of the Preslar-Hewitt Building. The building was recognized by the National Register of Historic Places by the US Department of the Interior and received the Award of Excellence from the Taylor Main Street Program. The two-story commercial structure is located at 321 and 323 Main Street and was built in 1914 by Hugo Hunke. The first floor has been used for businesses and offices over the years. Detailing includes pilasters, capitals, transoms, decorative tile work, and an entablature with dentil course. The building was recorded as a Texas Historic Landmark in 2004. The second story was renovated to accommodate the Jayroe family as their Taylor home. (Courtesy of Calvin and Anna Jayroe.)

Henry Bell and Alice Schieffer Seiders were married in January 1884. Henry came to Taylor with the railroad and was instrumental in the founding of the Presbyterian Church.

The daughters of Henry and Alice Seiders posed for a picture in 1890. From left to right are Eddie, Hattie, Alice, and Emma.

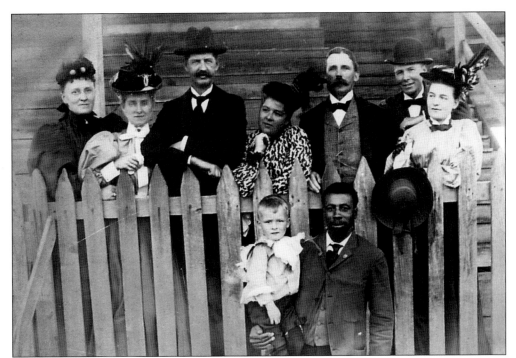

Individuals gathered at the fence to pose for their portrait include, pictured from left to right, Mrs. James Neil; Mrs. Betty McClure Robertson, Ed Robertson, Mrs. Harry Mendel, Joe Siedel, first president of Taylor National Bank, Harry Mendel, and Beth Booth Nelson. In front are C.H. Booth Jr. and a man everyone knew as "Lott."

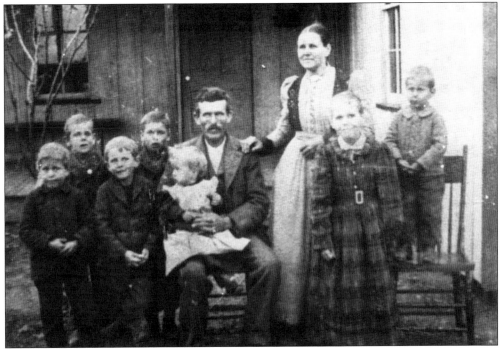

Stauffer family members are posing in front of their home. (Courtesy of Erwin Stauffer.)

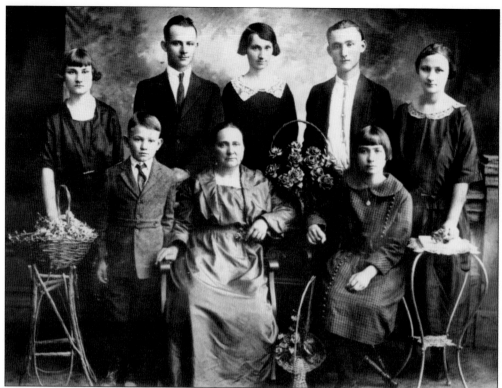

This is a portrait of the Frances Blaha Kotrla-Lorenz-Shiller family. It is said that when Mr. Kotrla passed away, he left his wife with "six children, two pennies, and a cow."

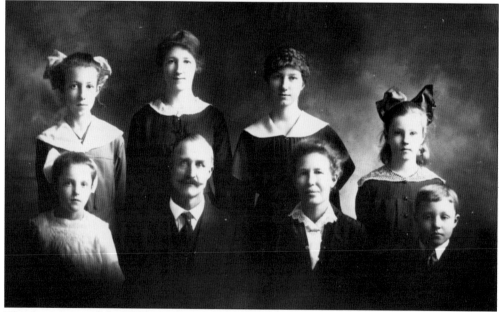

This is a portrait of the Walfred Johnson family. From left to right are (first row) Mildred, Walfred, Emma, and Walter; (second row) Frances, Esther, Marion, and Eunice. (Courtesy of Jimmie and Carol Ann Preuss.)

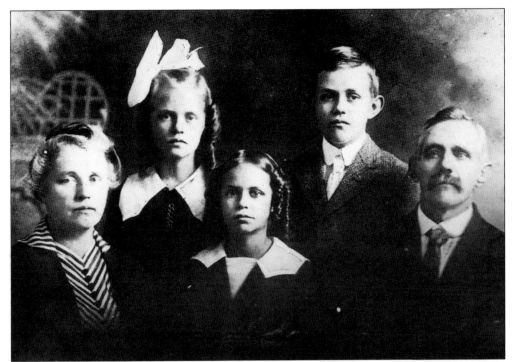

This is a portrait of the August Ahlgreen family. From left to right are Martha, Mildred, Bennie Marie, Arthur "Swede," and August. (Courtesy of Jimmie and Carol Ann Preuss.)

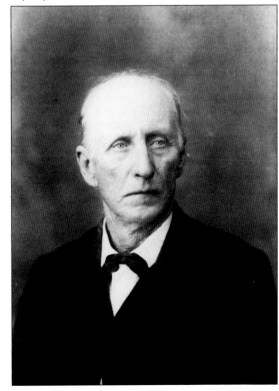

This photograph of David Hutchinson McFadin was taken in the 1890s. Hutchinson was a veteran of the San Jacinto War of 1836. He was one of the first settlers in eastern Williamson County. He owned a large homestead west of Circleville on the San Gabriel River.

The three daughters of G.M. and Josephine Kuykendall posed for this picture. They are Ruth Kuykendall McLaughlin, Agnes Kuykendall Arledge, and Pearl Kuykendall Lannen. Ruth and Hugh McLaughlin raised their family south of Taylor, Agnes and Clyde Arledge raised their daughter west of Taylor, and Pearl and Harry lived northwest of Taylor and had no children. (Courtesy of Joanne Rummel.)

"Schneider," whose name was actually Karl Jackel, was in charge of ringing the bell at St. Mary's. He was the official bell ringer for years. It was said that he was such a small man that sometimes he would go up with the rope. He took this job very seriously.

Four

HISTORICAL HOMES

The State Historical Survey Committee Official Historical Medallion was presented to the family of A.V. Doak, who was Taylor's first doctor, the organizer of mule-drawn streetcar line, a civic leader, and the father to Dr. Edmond Doak. Built in the 1860s, the home was a ranch-style forerunner home at 600 West Seventh Street.

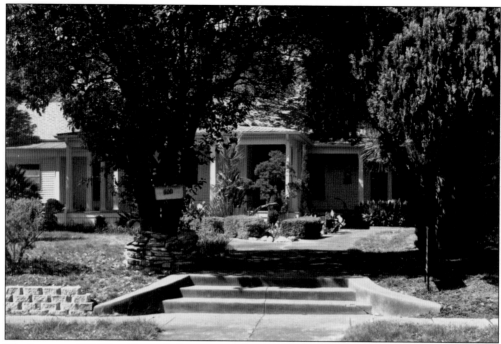

The home at 600 West Seventh Street was also an office for Dr. Edmond Doak. It was sold to the Dr. Frank Ruzicka family.

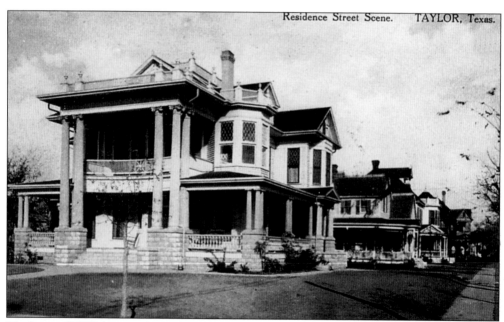

The home of T.W. Marse was located on the corner of Sixth and Main Streets at 104 West Sixth Street. The picture of the home was taken in 1911. The Marse family owned several businesses, including a dry goods store, a saloon, and a grocery store, and were part owners of the Hotel Blazimar.

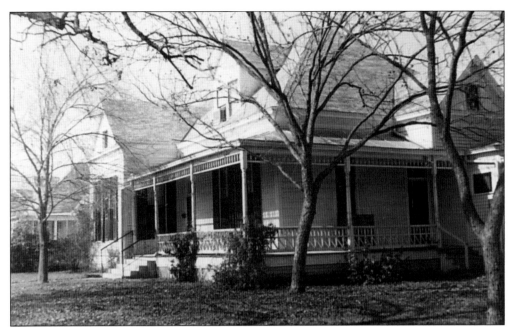

The H.C. Mantor home is located at 1118 West Seventh Street. Mantor was an attorney and a banker. His daughter Ruth graduated from Taylor High School and, after graduating from college, returned to Taylor to teach English. She wrote a book about Taylor and was a respected educator.

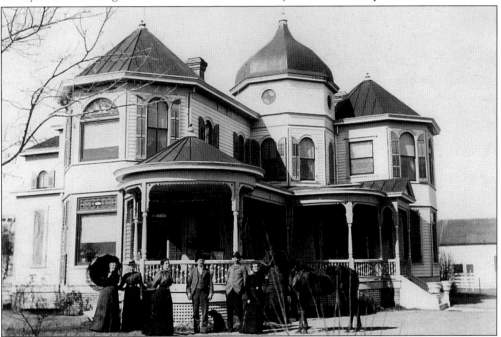

The G.M. Booth home was located at 2112 West Lake Drive. This image shows Booth family members with their horse in 1900. This home played host to many parties over the years. The John Clark family purchased the home, and after John Clark and his wife, Eunice, passed away, their daughter Sherry Clark Nichols came home to take care of this amazing home. The Clark Mansion is the site of many parties and weddings year-round.

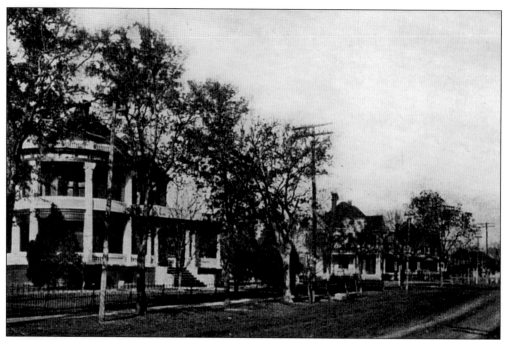

In 1911, 721 Davis Street was home to Colonel Bland and his family. Colonel Bland was born in Zanesville, Ohio. He married L. Augusta "Gussie" Schultz, and they moved to Taylor to raise their family. The Colonel was born in 1848 and passed away in 1933.

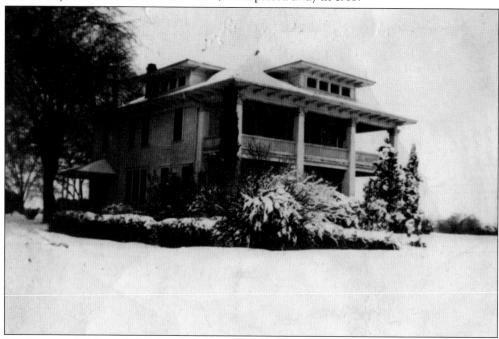

The Herman Wolbrueck home was built just north of Taylor in 1914. The picture of the snow-covered yard was taken on January 14, 1944. According to weather observer Herbert Patterson, this was the heaviest snowstorm on record in the Taylor area. The Wolbrueck family still resides in the home. Several movies have been made in the yard area.

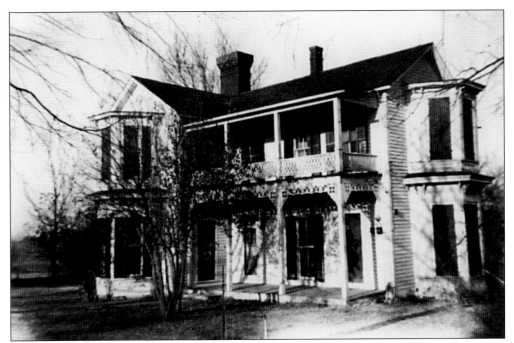

On Rice's Crossing Road, south of Taylor, J.B. Pumphrey built the family home. Henry Pumphrey moved to Taylor and lived on Lake Drive in the later years. Their three children were Ella Pumphrey Jez, Cissie Pumphrey Pierce, and Henry Jr.

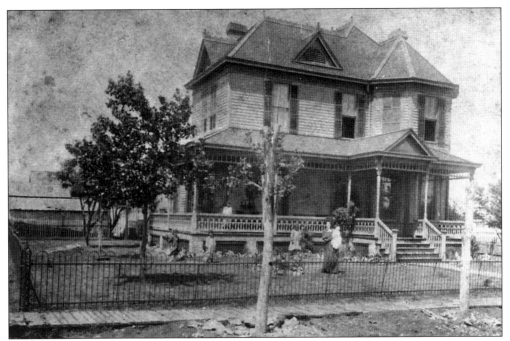

In 1894, this was home to the Henry Seiders family. The second floor of the home burned, but the ground floor was salvaged. Bill and Claire Maxwell purchased the home and converted it into the popular Talbot Street Bed and Breakfast.

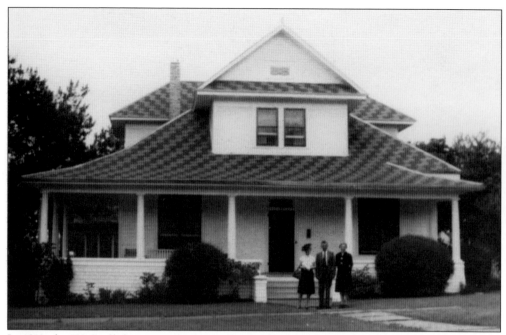

In 1911, the T.J. Duffy home was built at 401 Washburn. In later years, the home was purchased by Safeway grocery store. At that time, the home was removed, and the Safeway store was built in its place. When Safeway closed, the City of Taylor purchased the building, and it is now home to Taylor City Hall.

The A.A. Zizinnia home was located at 905 Davis Street and was one of the most prestigious homes in Taylor. The Zizinnia family was part owner of the Hotel Blazimar. The home is no longer owned by the family.

The home of R.E. and Sicily Threadgill was located at 904 Davis Street on the northeast corner of Ninth and Davis Streets. The home was built in 1918. Two of the grandchildren, Dean Threadgill and Charlotte Howell, are living in the Taylor area. (Courtesy of Dean Threadgill.)

The former home of Tom and Elizabeth McConnell home is located at 1001 Fowzer Street and was built in 1909. Mr. McConnell was a constable and mail carrier in the Taylor area. Bill and Claire Maxwell purchased the home in 1981.

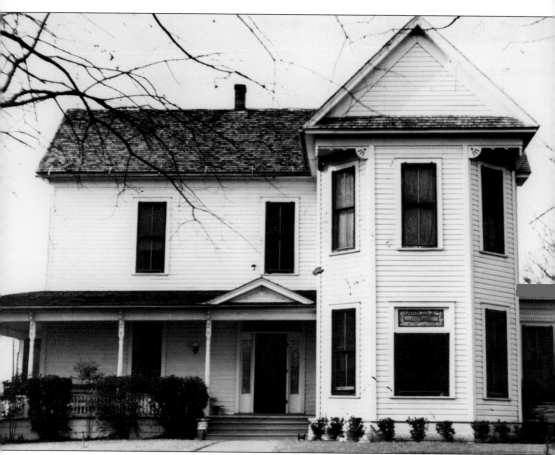

This was the home of the Frank Dahlberg in 1949. Now located in the 1800 block of Main Street, the home once faced the opposite direction on the Old Granger Highway and was turned around after Highway 95 was at the back of the house. This has been home to the Dahlbergs, coach Bill Ford and family, a restaurant, and today is owned by Keith Hagler as offices.

Five

CHURCHES

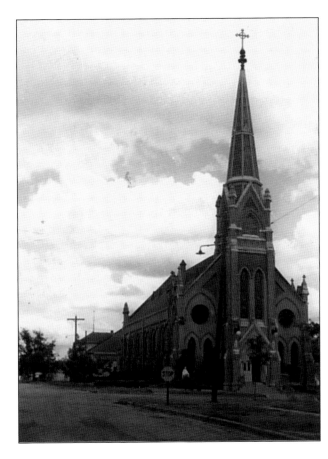

St. Mary's Catholic Church is located on the corner of Washburn and Fourth Streets. It was founded in 1878 and has more than 900 families today. The church is a member of the Roman Catholic Diocise of Austin.

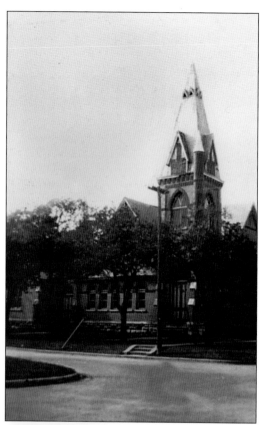

The First Christian Church was founded December 9, 1877, with 22 charter members. They originally met in the Odd Fellows Hall. In 1891, the present-day Gothic Revival church was built. The church is shown left with its bell tower, and shown below is the church without the tower; the tower was torn off during a tornado.

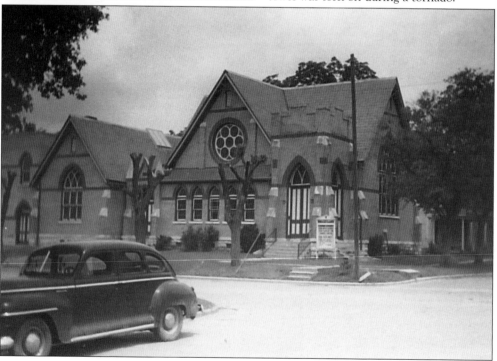

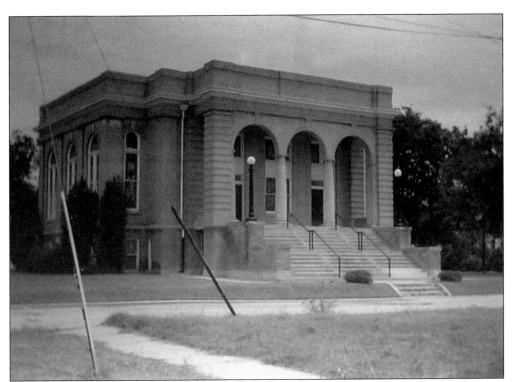

First Presbyterian Church can be traced back to 1876 when the church in Georgetown and Taylor had one preacher that led both congregations. In 1878, property was purchased, and the sanctuary was completed by Thanksgiving of that year. With the growth of the congregation, the new brick church was built in 1912–1913. The church is located at 114 West Sixth Street. This group of men belongs the Presbyterian men's Bible class of 1927. There were 418 in attendance.

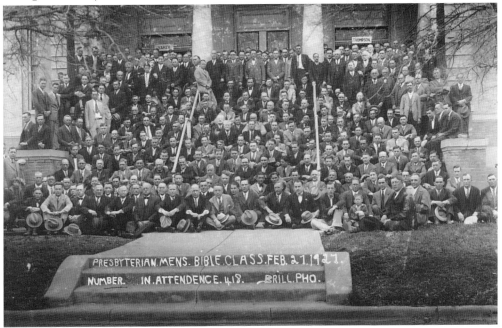

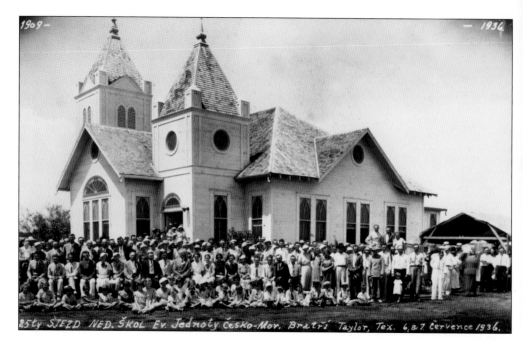

25ty SJEZD NED. SKOL Ev. Jednoty Cesko-Mov. Bratri Taylor, Tex. 6,a 7 Cervence 1936.

During the 1880s, many Czech Protestant immigrants who settled in the Taylor area were members of the Unity of the Brethren, founded in 1457 by followers of the Czech reformer and martyr Jan Hus. The local Brethren found it difficult to worship in the area's Protestant churches because of a language barrier since most were conducted in German or English, not the native Czech. As a result, the immigrants joined together to revive practices of the Unity of the Brethren and worship in their native language. The Taylor Brethren Church was formally organized in 1895. They first used West Taylor Lutheran Church until in 1902, when they purchased property. Czech language was used until 1967. Below is a picture of the first Brethren Church in 2011. A historical marker was erected on the property in 2005.

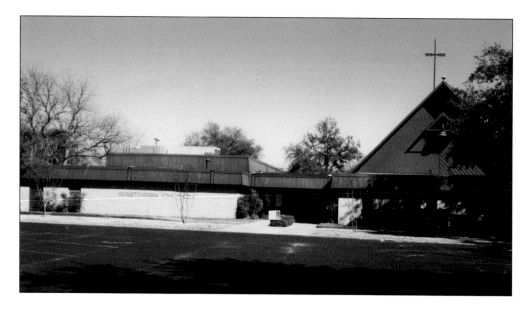

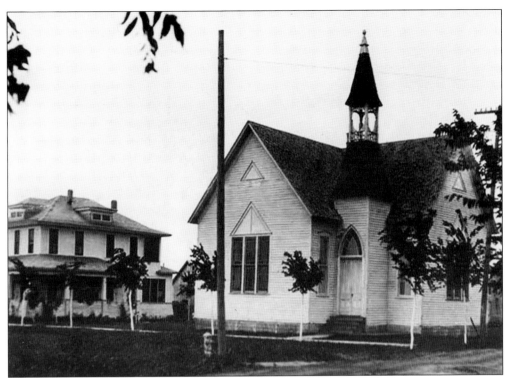

The Swedish Methodist Church North was founded in 1900. They bought a chapel from a disbanded group. The church was moved to the current site in 1911. In 1935, English became the language used during services. The church has had 28 pastors. These photographs show the church as it looked when it was first established and as it appears today.

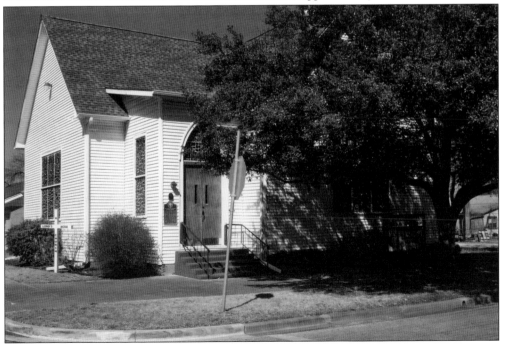

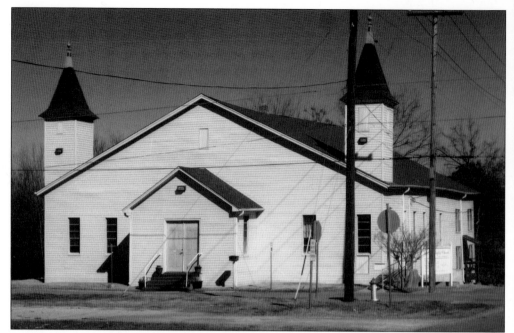

First Baptist Church, located at 300 North Robinson Street, was established 17 years after the end of slavery. This is a family church that was established in 1879 and is now 132 years old. The church was first called Mr. Aria Baptist Church, and one of the trustees was C.H. Pickett, the father of Bill Pickett, the rodeo star. It is now First Baptist Church and has been served by 27 pastors.

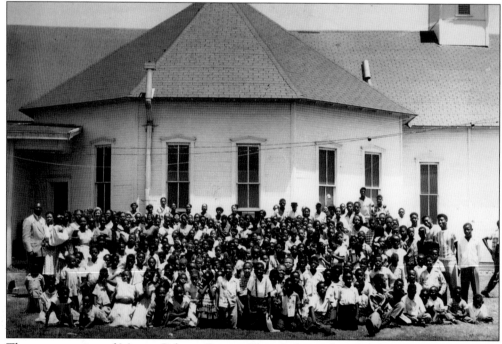

The congregation of Mount Calvary Baptist Church, located at 602 Symes Street, is in the early 1950s. The church is still located at the same spot, and church services are held each Sunday.

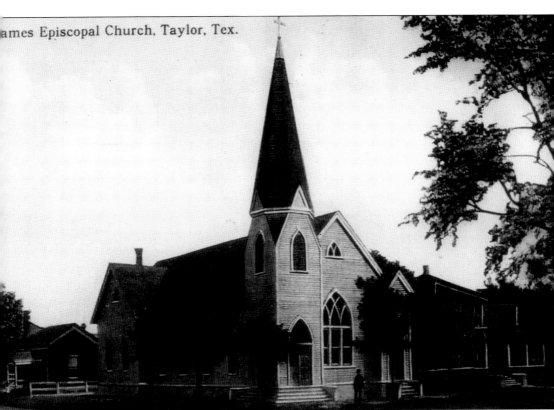

ames Episcopal Church, Taylor, Tex.

The first service of the St. James Episcopal Church was held in 1878. The organ was installed in 1914 and is still in use. The structure retains its original stained-glass windows and interior paneling. The church received the historical marker in 1969. The church is located on the southeast corner of Davis and Seventh Streets.

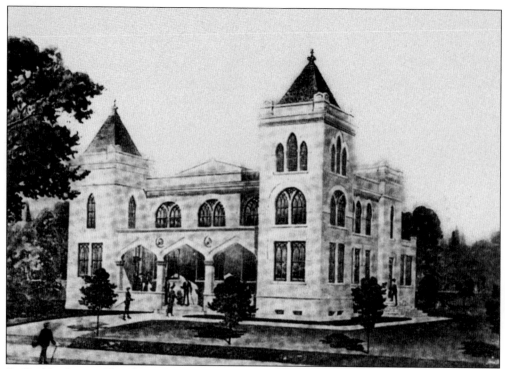

St. Paul Lutheran Church was built in 1917 and was located on the corner of Sixth and Fowzer Streets. There is a marker on this corner showing where the original church was built. Ernest Groba was the contractor.

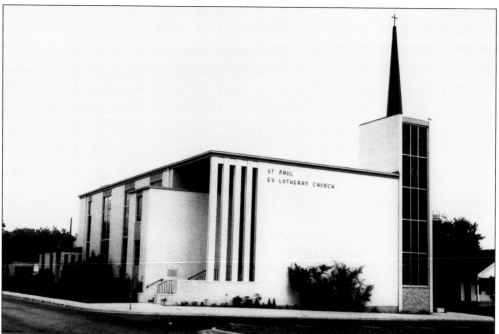

The new church is located at the corner of Seventh and Fowzer Streets, just a block away from where the original church was. Beside church services, they have a daycare and a school.

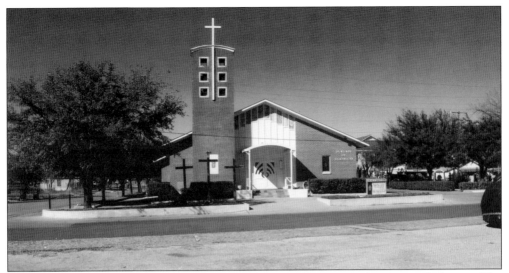

Our Lady of Guadalupe Parish is located on the corner of Sturgis and Rio Grande Streets. The parish was founded in 1914. Today, the congregation includes over 500 families.

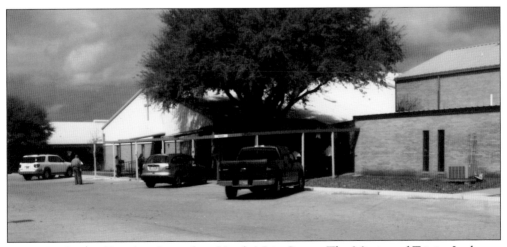

Trinity Lutheran Church is located on North Main Street. The Mission of Trinity Lutheran Church is to touch the lives of people everywhere with the good news, which promises inner peace and eternal salvation in Jesus Christ. Before the new church was built on Main Street, the church was located on Sloan Street.

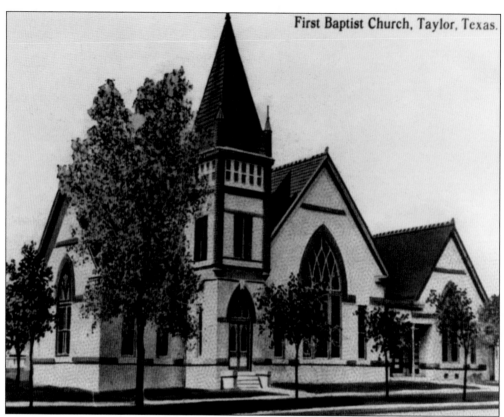

First Baptist Church, Taylor, Texas.

First Baptist Church, founded in 1882, is one of Taylor's earliest churches. The church was originally located at the corner of Fowzer and Sixth Streets. The new church was built in 1948 at the northwest corner of Davis and Seventh Streets.

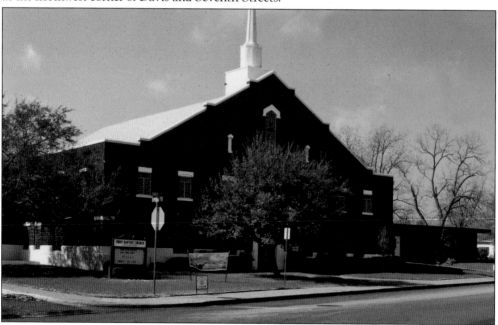

Six

Physicians and Clinics

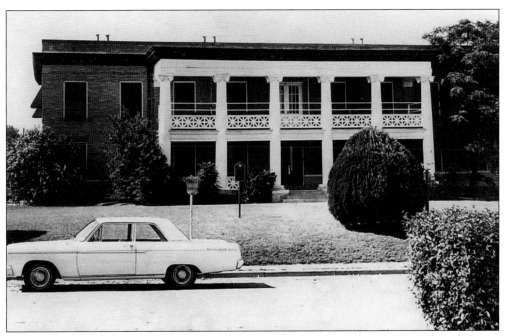

In 1915, Dr. G.A. Wedemeyer occupied the Wedemeyer Hospital, located at 800 West Seventh Street. He came to Taylor in 1905. The hospital was continuously operated until 1957, when it became a retirement home. The building has been recognized by the Texas Historical Commission.

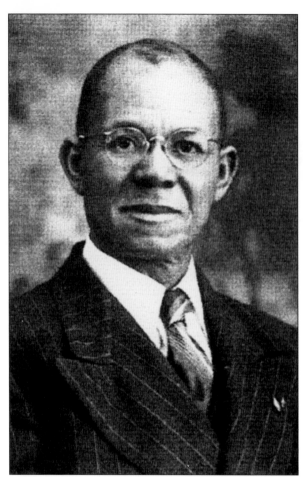

Dr. James Lee Dickey originally started his practice in 1920 at his home. His practice grew and led to a 15-bed hospital. He was the only black physician in Williamson County at this time. He was honored as the Outstanding Citizen of Taylor. The Blackshear–O.L. Price Ex-Student Association has made plans to renovate the home of the late Dr. Dickey and convert it into a Museum of African American history and art.

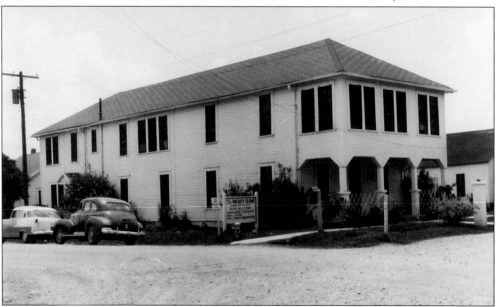

Freda Arnell, born February 17, 1890, in Svenarum, Sweden, came to Taylor in 1914. She received her nursing training in Fort Worth at the St. Joseph Infirmary School of Nursing. She served in France during World War I, the only Williamson County nurse to do this. The image shows her in her army uniform. They were not permitted to carry a purse or handkerchief, but the uniforms included lots of pockets. Nurses were also required to wear gloves. After the war, she was still an active nurse and worked on Elliott Street. Occasionally, she would deliver babies in their homes. One such baby was Arnell Kelm Gamble, born February 28, 1936. Freda had asked Mrs. Kelm (Effie Shelgren Kelm) if she had a baby girl to please name the baby Arnell. She said she would never have children and she would love to have someone named after her family. It was a girl, and Mrs. Kelm honored Freda by naming the baby Arnell. Arnell Gamble said Freda never forgot her birthday and sent her birthday cards until she passed away on March 10, 1949. Other nurses that worked in the Taylor hospitals in the early days were Hilda Floeckinger, the superintendent of nurses at Floeckinger Sanitarium; Kate Mitchell Grunau; Edna Hylich; Esther Johnson; Ellen Larsen; Erna Pfluger; Mamie Rusch; the superintendent of nurses at Physicians and Surgeons Hospital; Ella Roegenbuck; Ida Steadman; Ethel Sanders; Ruth Sasse; Rose Mikus Swenson; Mrs. Frank Sykes; and Bertha Mae Hanstrom Kollman, the superintendent of nurses at Johns Community Hospital.

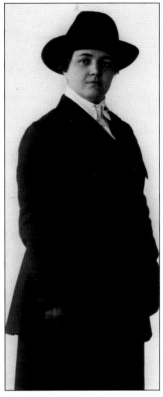

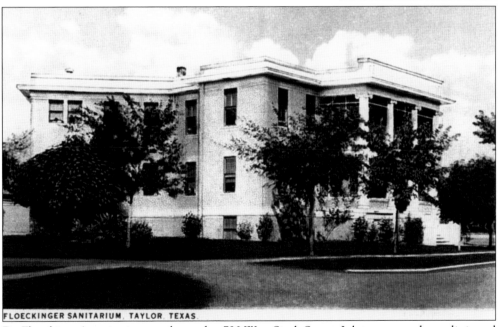

FLOECKINGER SANITARIUM, TAYLOR, TEXAS.

Dr. Floeckinger's sanitarium was located at 720 West Sixth Street. It later was used as a clinic and hospital. A fire caused the hospital and clinic to close, and the east part of the hospital, which was not destroyed by the fire, was used as apartments. The building has since been removed. (Courtesy of Claire Maxwell.)

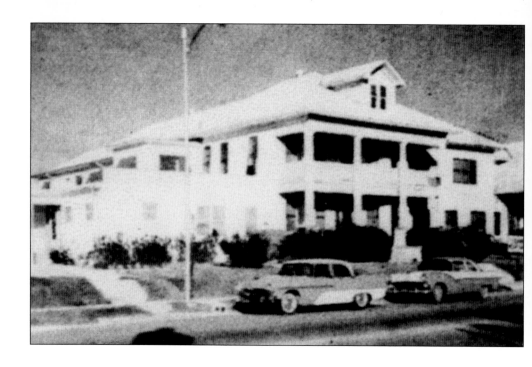

Stromberg Hospital was located at 813 North Main Street and, unfortunately, has been torn down. Many middle-aged people were born in this hospital. Below, Dr. E.W. Stromberg is pictured in his office at the Stromberg Clinic and Hospital in 1947.

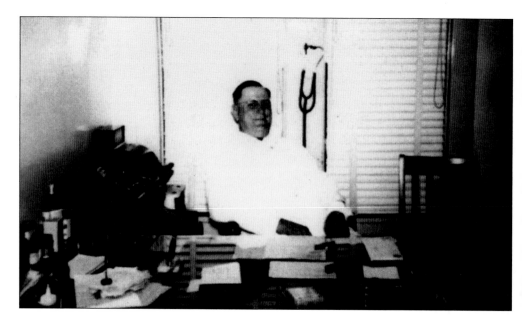

Seven

EDUCATION

The high school on Seventh Street has been used as a high school, middle school, office space, and the Duck Museum. The high school moved to North Main Street and is now in the process of building a new school on Farm to Market Road 973.

The Twelfth Street School housed students from the first grade to the sixth grade. There was a candy store across from the cafeteria that tempted the students, who would wait impatiently for their lunch break, at which time they were allowed to buy candy. The school had a fire escape, and the students in Kathryn Nowlin's class could slide down the tunnel on Fridays if they made a 100 on their test. The school is no longer there; they have replaced it with the School Administrative Building.

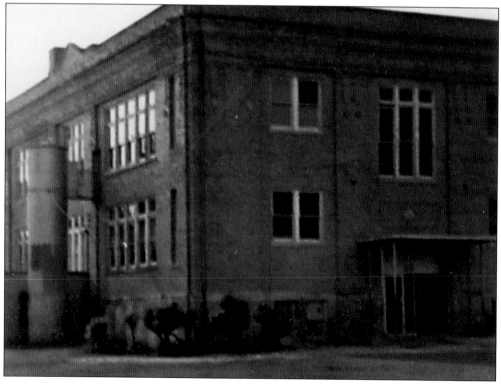

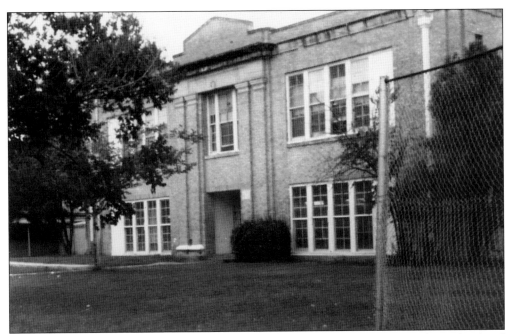

West End Elementary School was similar to the school on Twelfth Street. Students that lived south of Seventh Street would attend the West End School, and the students north would go to Twelfth Street.

St. Mary's Catholic School was opened in August 1896 with 80 students. This is the oldest Catholic school in Williamson County. The school and the church are both wonderful examples of classic architecture. The Dominican Sisters brought religion, discipline, and solid education to the students of the school. The school has become an integral part of Taylor and surrounding communities.

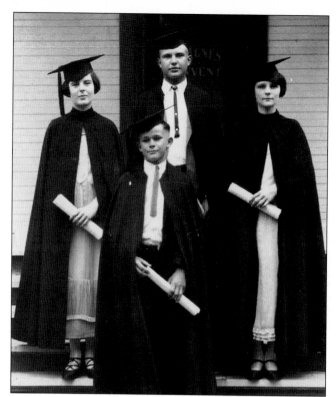

The St. Mary's Catholic School's graduating class of 1926 included, from left to right, Grace Dellinger, Alfred Bammel (in front), Otto Bachmayer, and Marie Riefco. (Courtesy of Jo Ann Bachmayer.)

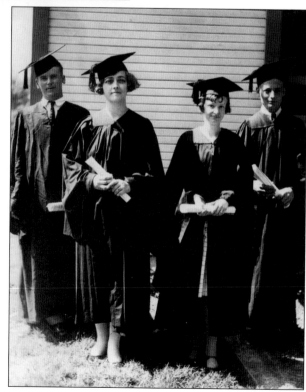

The members of St. Mary's Catholic School's graduating class of 1927 were, from left to right, Ernest Zimmerhanzel, Margaret Sykes, Olive White, and John Hafernik.

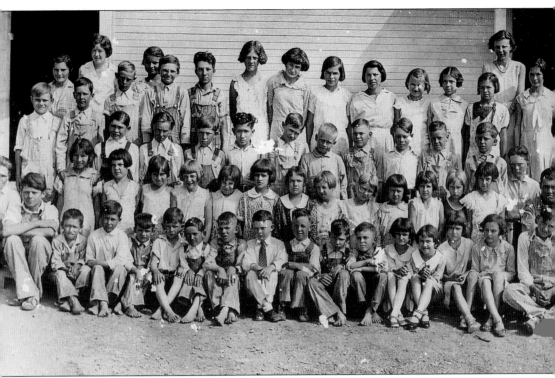

When the teacher told the students that their picture would be taken the next day, Erwin Bachmayer (first row, center) told his mother. She made him dress up and wear a tie—the only one in his class. This class picture was taken during the 1931–1932 school year. (Courtesy of Carrol and Carol Bachmayer.)

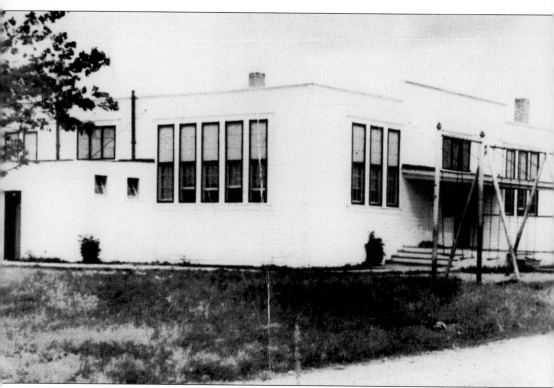

The Alamo School was built in 1918 for $3,000 and was was demolished in 1952. A new school, Southside School, was built in 1952 at a cost of $43,000. Both schools were on the same site, located at the corner of Rio Grande and Sturgis Streets. The school had the first through sixth grades. The students attended the high school on Seventh Street after they finished the sixth grade.

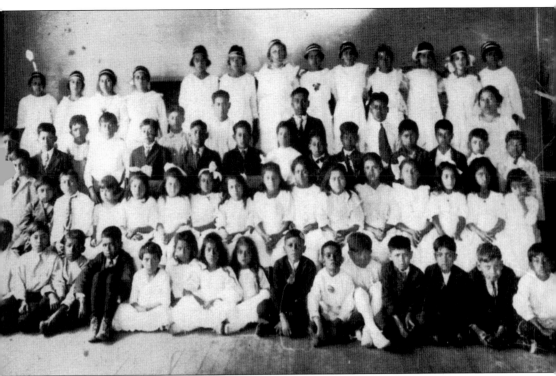

Students at the Alamo (Mexican Ward) School, also know as South Side Elementary School, are pictured in the spring of 1921. The principal was Miss Salem Ortega Simplicio. Some of the students have been identified, including Petra Ramos, Margaret Ramos, Victoria Ramos, Elvioa Ortega, Maclovia Rivas, Lito "Paul" Salinas, Jesse Silva, Jesse O'Campo, Arnulfo Salinas, Esteban Limon, Santiago Salinas (Chago), Willie Fuentes, Susie Fuentes, Maria Galindo, Juanita Salinas, Angel Amesquita, Felipe Amesquita, Tona Limon, Orfelina Fuentes, Lilia Guiterrez, Leon Rivas, Luis Galindo, and Eddie Fuentes. (Courtesy of Gumi Gonzales collection.)

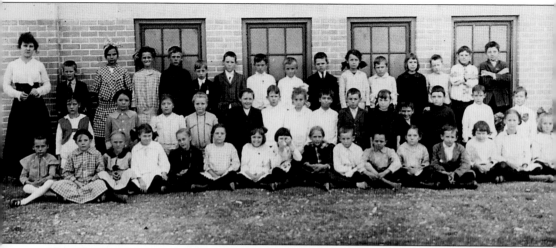

The 1914 class picture was taken at Twelfth Street School. A total of 12 of these students graduated from high school in 1923. Pictured from left to right are (first row) Edna Lumpkin, Jessie Calvert, Ellen Ahlgreen, Mollie Gray, Helga Engstrom, Amanda Reimer, Lorene Johnson, Helen Barnes, Della Drueger, Ewell Petway, Chester Revis, Mary Alice Slagle, Tom Robertson, Nellie Hawkey, Noreen Johnson, and Mimmie Kaiser; (second row) Gladys White, Verdie Allison, Edna Ahlgreen, Myrtle Tennill, Douglas Bugg, William Campbell, Lillie Orsak, Roy Falkenberg, Raymond Orsak, Elsie Jenson, Harold Seider, Edward Barlow, J.P. Humble, and Willie Janek; (third row) Raymond Soloman, Euphirie Tipps, Margaret Barr, Alfred Jenson, Armond Ginther, Charley Gossett, Joe Mares, Delvin Krueger, Ed Douglas, Lena Theil, Kenny Schultz, Lucille Kollman, Hobert Nixon, Jim Teaff, and Vaness Cogburn.

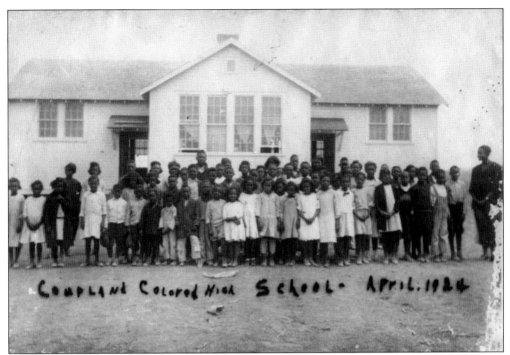

Students are pictured in front of the Coupland Colored High School in April 1924.

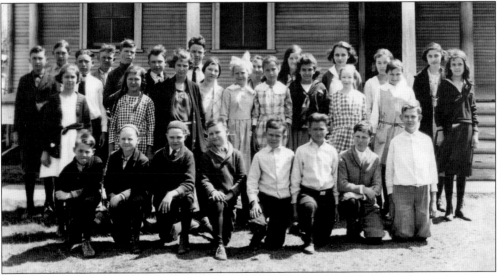

The fourth-grade class of 1916–1917 had 38 students. Pictured from left to right are (first row) Davis Durland, Chester Revis, Neil Hague, Langdon Richter, Hassell Arnold, Roy Wilson, Ward Gossett, and Elmer Burns; (second row) Dudley Mann, Joe McDuff, Albert Hadler, Homer Medlock, Gilbert Fritz, Perry Peterson, Lillian Meredith, and Mary Lee Vidler; (third row) Gladys Hymer, Blanche Vedenburgh, Margaret Voelker, Ruth Speegle (Mrs. Morgan), Mildred Ahlgreen, and Edna Geldmacher; (fourth row) Miss Julia Stewart, Fannie Mae Miles (Mrs. Dick Bartz), Edwina McLendon, Frances Robertson, Thelma Phythian, Nellie Hankey, and Annie Jensen; (fifth row) Mary Goetz (Mrs. Ernest Groba), Myrtle Tennill, Pauline Gerding, and Marguerite Barr; (sixth row) Merritt Todd, Homer Gilstrap, Hans Jensen, William Wenk, and Benton Ladewig.

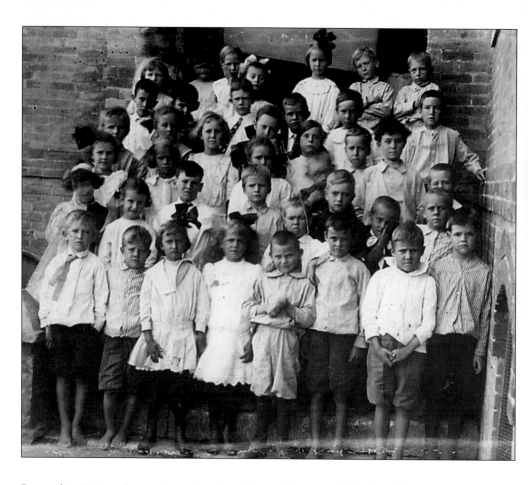

Pictured in 1912 are first-grade students from Taylor Elementary School and Blackshear Elementary School in Taylor.

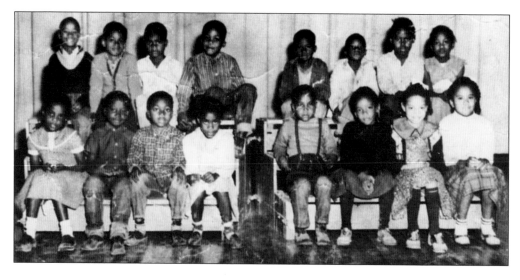

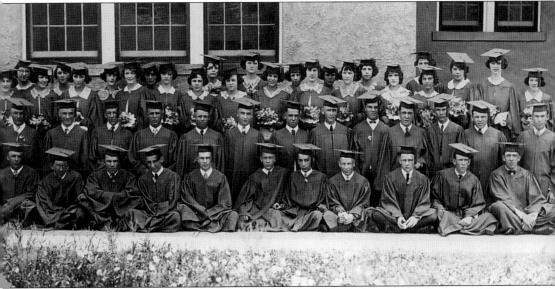

The graduating class of Taylor High School 1923 included the following students, pictured from left to right: (first row) Willie Campbell, Willie Janek, Roy Falkenberg, Louis Aderholt, Ewell Petway, Red Harold Harris, and Jack Underwood; (second row) Benton "Pete" Starnes, Ronald Todd, Willie Grau, Arthur "Swede" Ahlgreen, Gilbert Fritz, Robert Scully, Walter Fritz, Willie Baker, Ed Douglas, Elmore Torn, J.P. Jake Hamblen, Harold Hamilton, and Byrom Rhinehart; (third row) Helga Engstrom, Winifred Tot (Gossett), Bess Caughron, Mary Thomson, Elsie Guyot, Maude Campbell, Hazel Hopkins, Bessie Peters, Bernice Helms, Ruby Taylor, Ruth McConnell (Wernlie), and Ruth Speegle; (fourth row) Ruth Mantor, Frances Dahlberg, Gertrude Norris, Merle Pipkin, Pauline Jowers, Vera Threadgill, Gladys White, Ella Weidenbaum, Bertha Sloan, Lucille Kollman, Viola Gross, Bessie Hamilton, Ella Schultz, and Gladys Threadgill.

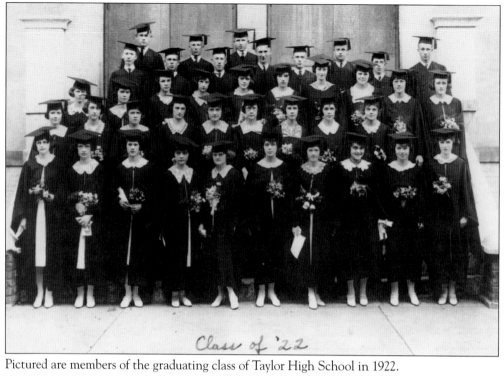

Pictured are members of the graduating class of Taylor High School in 1922.

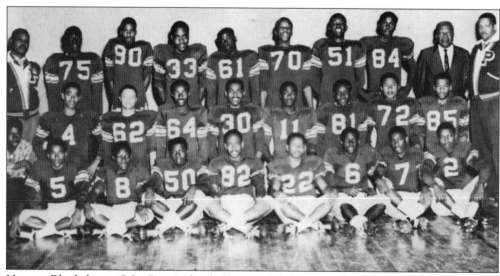

Here is Blackshear–O.L. Price's football team. Unfortunately, the names of the players are unidentified.

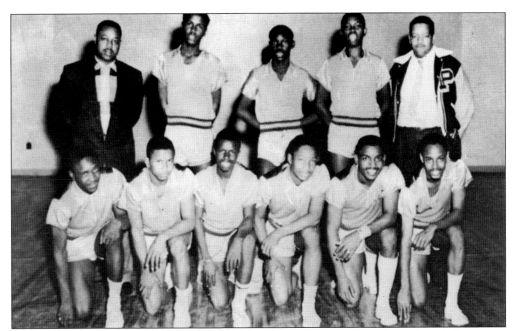

Here is the basketball team from Blackshear–O.L. Price. Those pictured are, from left to right, (second row) coach Edward Elder, Lee Washinbton, Gene Ross, Sidney Smith, and coach Melvin Chambers; (first row) Tim Fredrick, T.F. Anderson, Otis Shaw, Roy Jefferson, Elzie Clark, and Herbert Henderson.

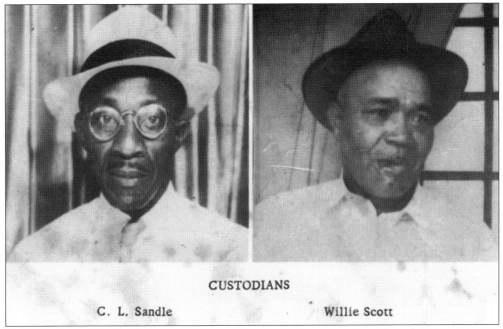

CUSTODIANS

C. L. Sandle Willie Scott

C.L. Sandle and Willie Scott were very well-known and respected gentlemen, beloved by the students. They were custodians at Blackshear–O.L. Price.

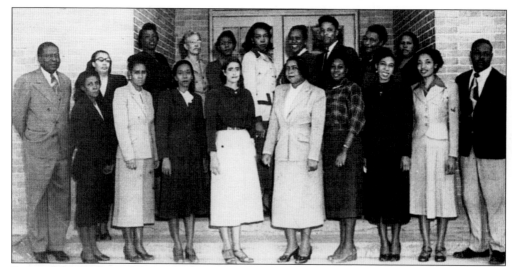

Some of the teachers that taught at Blackshear–O.L. Price school were Mrs. L.E. Hennington Bass, second grade; Mabel Sauls, fifth grade; Mrs. O.L. Price, first grade, Zenobia Garrett, fourth grade; Beulah Marie Johnson, seventh grade, Mrs. Thomye Houston, eleventh grade; Tommy Steps, fifth grade; Ruby Hatcher, eighth grade; and Mrs. Algie Harrison, first grade. (Courtesy of Jennifer Harris.)

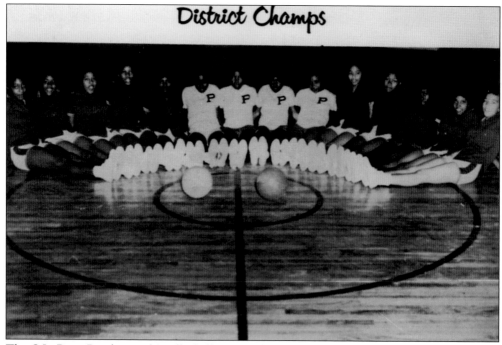

The O.L. Price Panthers girls' volleyball team really fought hard during the season, and with a great team effort and support from their families, the girl became the champion volleyball team in the district.

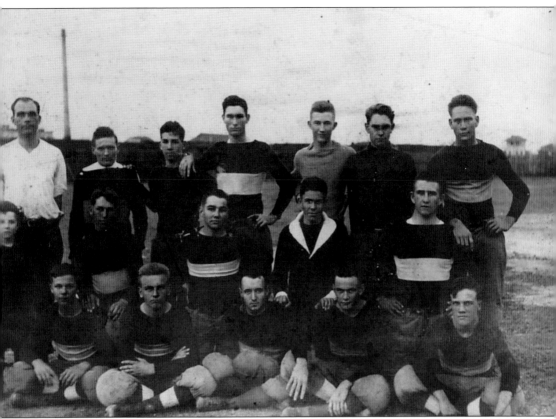

Coach T.H. Johnson wrote in an article that more that 1,000 boys had played a role in building the football fortunes and records of the Taylor Ducks during the period from 1915 to 1975. The ducks played 592 games during the 61-year period. Total number of games won by the Ducks was 386, and the top scoring Duck team in one season was 483 points in 12 games in 1960. Here is the 1915 Taylor High School's fighting Ducks. There is the following saying in Taylor: "Once a duck, always a duck."

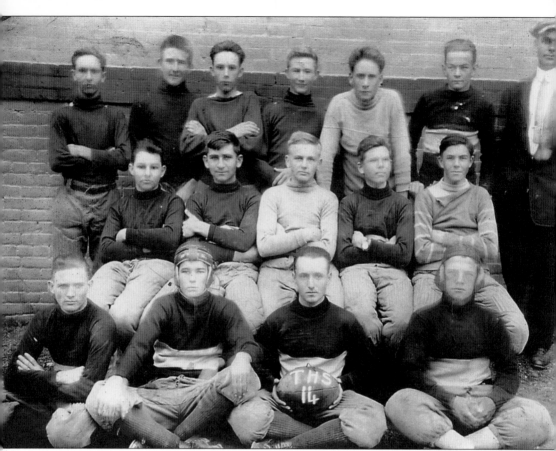

Since 1914, Taylor has always been a sports-oriented town, with support coming from students' families and friends. Football players at this time did not have all of the protective gear that is used today. In the line up, Lawrence Mantor and Leon Bergstrom played center for the team. The right guard was William Goff, and the left guard was Lewis Sams. The right and left tackles were Porter Savage and Will Fairchild. The right and left ends were Lat McCornell and Steve Atchison. The quarterback was Leonard Johnson, with Vernon Adanis and Tom Sladle acting as right halfbacks. The left halfback was Templeton McCalin, and the fullbacks were Gordon Talley and Van Coupland. The substitutes were Nathan Simmons and Clarence Ploeger.

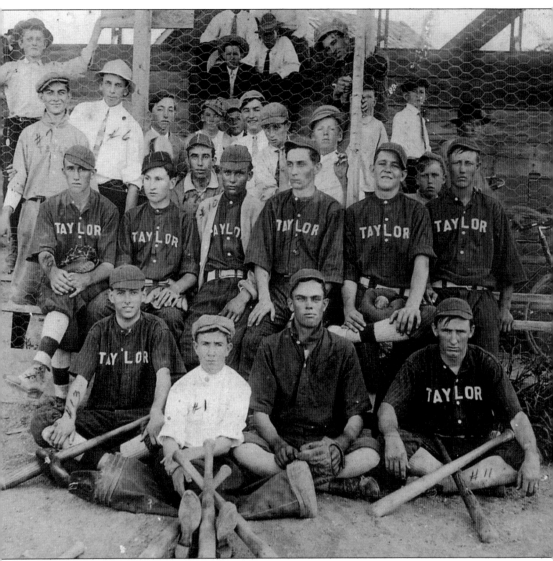

The Taylor baseball team of 1917 and some of its supporters look ready to play. The team members are Robert Burnett, Patrick O'Donnell, Herschel Gray, Dan Walker, John Spiegel, Richard Rush, Albert Braun, Howard Dodd, Walter Schelnik, Bob Spiegel, Joe O'Brien, Luke Fullerton, and Earl Duce.

During halftime at football games, marching bands perform on the field to entertain the crowd while the football players take a break. This is halftime at a Taylor football game at Memorial Field. The skit was performed by Raymond and Irene Schroeder (parents of Brenda Gola and Wayne Schroeder), Claude and Lois Patterson (Claude and his brother Herbert owned Patterson Brothers in Taylor), Don and Mary Adile Smith (parents of four children including Jan Raesz of Taylor), and Howard and Geneva Smith and their children. One of the little girls is Ann Brueckner.

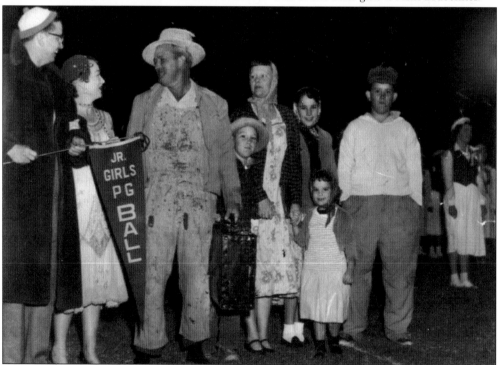

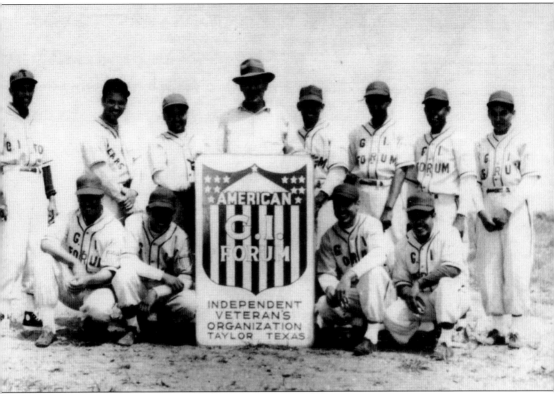

Here is the American G.I. Forum, Independent Veterans Organization's baseball team in Taylor, Texas, in 1949. Listed in no particular order, members included Felipe Martinez, Amastacio Robledo, Olganio Rendon, Manuel Velasquez, Lolo Salis, Thomas Malatinez, Barnabe Cubes, Eugenio De La Rosa, Juan Buentillo, Tomas Vega, Rojelio Garza, and Jimmy Quebas. (Courtesy of Gumi Gonzales collection.)

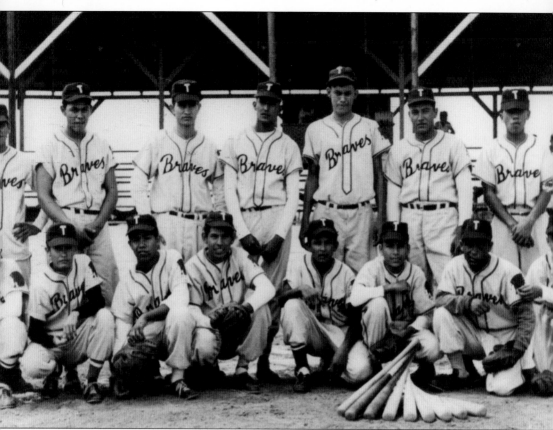

In 1955, the Taylor Braves played their games in Hidalgo Park. Sports fans traveled to Taylor to watch the Braves play. Some of the team members are Luise Navarro, Manuel Velasquez Jr., Cruz Velasquez, Jesse Chavanna Jr., Jesse O'Compo Jr., Joe Cortinas, Tony Rivera, Ernest Ariola Sr., Pete Valdez, and Joe "Pepe" O'Compo. (Courtesy of Gumi Gonzales collection.)

Eight

PARADES AND FESTIVALS

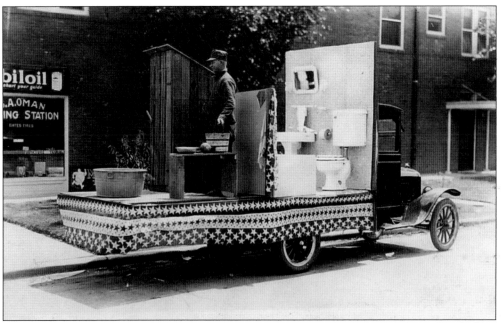

Parades and festivals have always been a major part in the lives of Taylor families. This "before-and-after" float was built on a 1900 truck and really does tell the story. One side is decorated with an outhouse, bucket, and the tub, and the other side has a commode, bathtub, and lavatory.

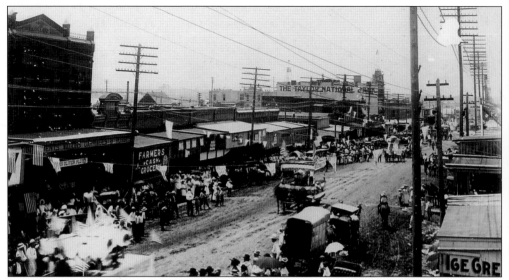

As early as 1906, parades were very popular with the citizens and the whole county. The parade is on Main Street heading south. In this picture, one can see the east side of Main Street.

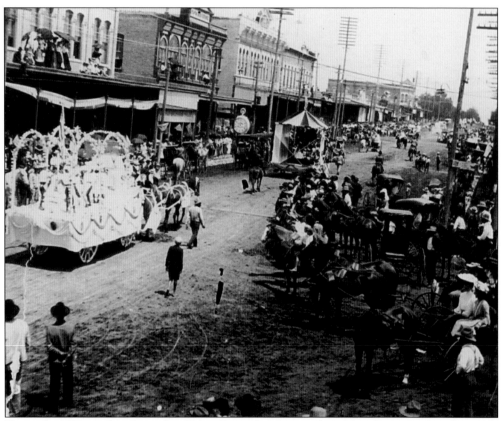

Here is the 1913 parade at Second and Main Streets heading north on Main Street. Look at the people sitting on the roof. This was a very festive time. Most of the ladies sat in their carriages to view.

This parade took place in 1939. Notice all of the people that are lined up to watch. Again, people are sitting in windows to watch the fun.

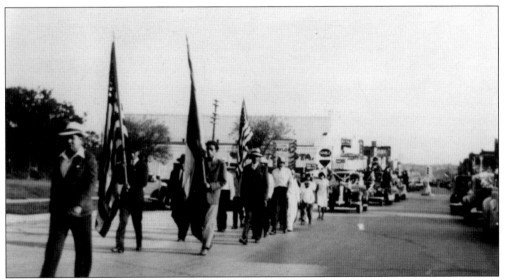

Here is Fiestas Patrias celebration on Main Street. Jesse O'Compo is leading the parade. Note how far back this parade is lined up. (Courtesy of Gumi Gonzales collection.)

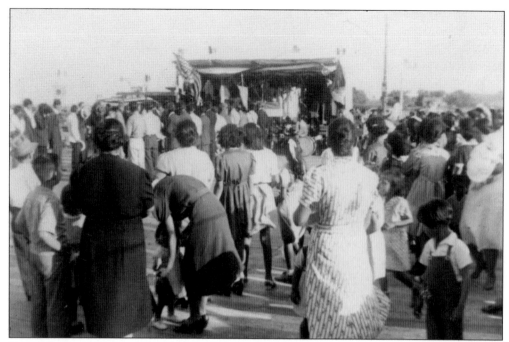

Fiestas Patrias celebration on Highway 79 and Gym Street was a big event with many forms of entertainment, great food and drinks, and fun for all. (Courtesy of Gumi Gonzales collection.)

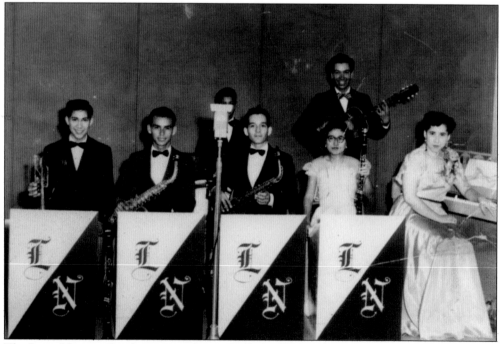

The Louis Navarro Band was a regular on Taylor's KTAE radio station. They played for many weddings and other events. (Courtesy of Gumi Gonzales Collection.)

The Fourth of July celebration in 1913 featured a hot-air balloon between Porter and Washburn Streets. Who would have believed there was a hot-air balloon in Taylor in 1913? Of course, this was the hit of the celebration.

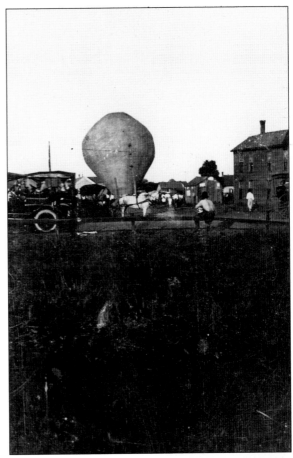

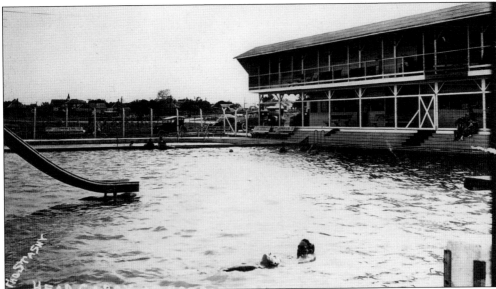

The Taylor Municipal Swimming Pool and Pavilion in 1920 was a place that everyone could enjoy. Shown here, someone is learning how to save a life.

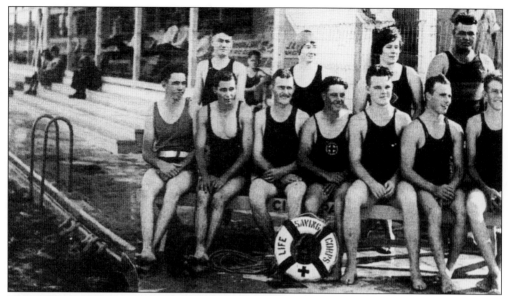

This is the Life Saving Corps at the Taylor Pool. These young people accomplished their goal and passed the course. With as many people as there were swimming in the pool, these lifeguards were really needed.

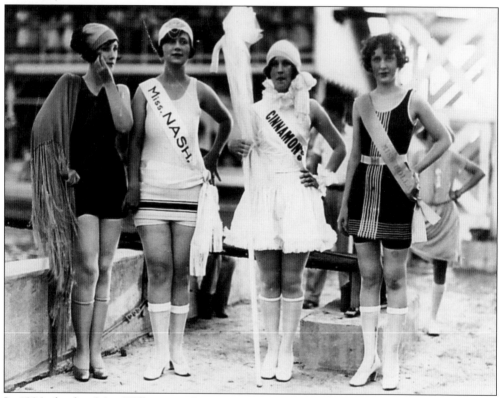

In 1926, the first Miss Williamson County Beauty Contest was held at the Taylor Swimming Pool. Here are four of the ladies that entered the contest. They are wearing sashes that show their sponsors. The local and county businesses helped support these ladies.

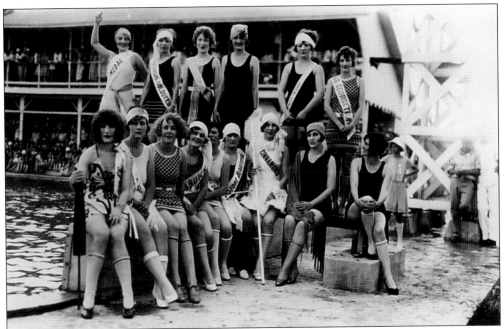

Here is another picture of the bathing beauties that graced Taylor. There is a group shown sitting on the left side, and one of those ladies is the very well-known Ruth McConnell Wernli. She taught tap, ballet, and piano lessons to many young people in the area. Ruth is the first beauty sitting on the left.

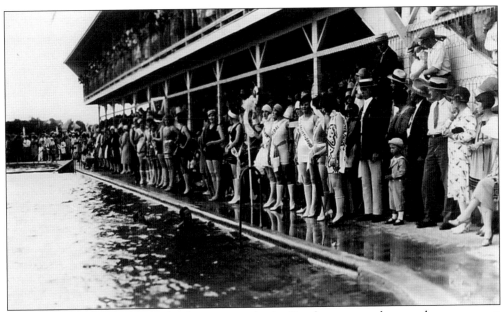

The ladies are lined up waiting for the contest to begin. People are everywhere, and some are even on the upper deck. This was a really big event, and spectators came from all over the county to watch their favorite lady win this title.

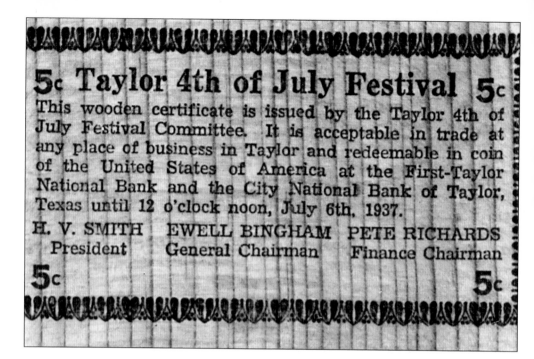

5¢ **Taylor 4th of July Festival** 5¢

This wooden certificate is issued by the Taylor 4th of July Festival Committee. It is acceptable in trade at any place of business in Taylor and redeemable in coin of the United States of America at the First-Taylor National Bank and the City National Bank of Taylor, Texas until 12 o'clock noon, July 6th, 1937.

H. V. SMITH — EWELL BINGHAM — PETE RICHARDS
President — General Chairman — Finance Chairman

5¢ 5¢

These are tokens that were given out at the July 4, 1937, festival. It not only recognizes the event, but it could also be used at any of the local businesses or redeemed at a bank for a nickel. H.V. Smith was president, Ewell Bingham was general chairman, and Pete Richards was the finance chairman of the festival.

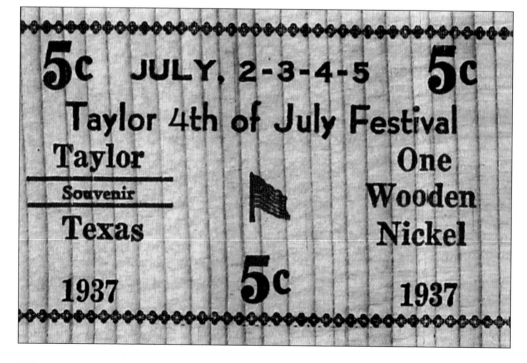

5¢ JULY, 2-3-4-5 5¢

Taylor 4th of July Festival

Taylor One

Souvenir Wooden

Texas Nickel

1937 5¢ 1937

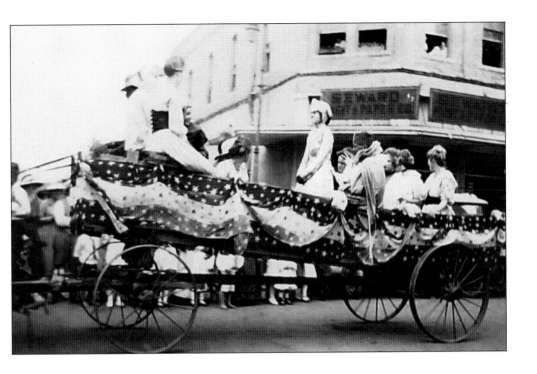

The wagon was really decked out for the 1918 Patriotic Parade, as were the ladies. The soldiers of World War I helped to make this a special day by marching in the parade.

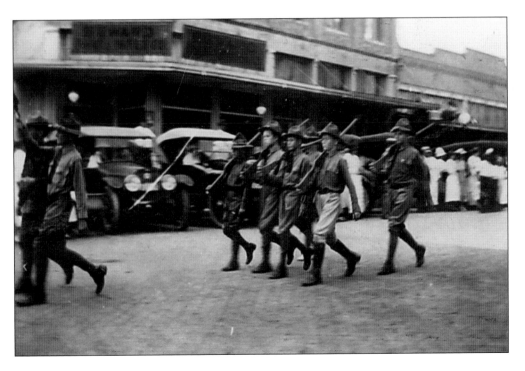

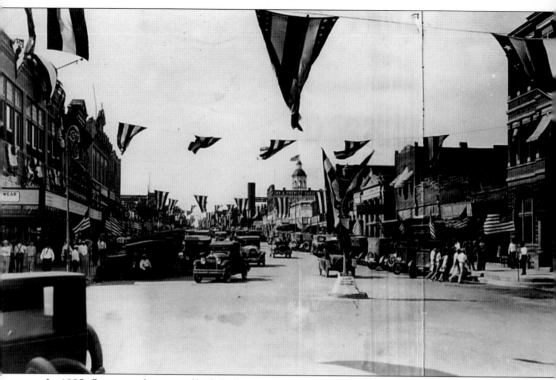

In 1925, flags were hung at all of the businesses, across the street, and even in the intersections. Looking north on Main Street from Second Street, visible are Ira A. Prewitt Hardware and the top of Taylor City Hall.

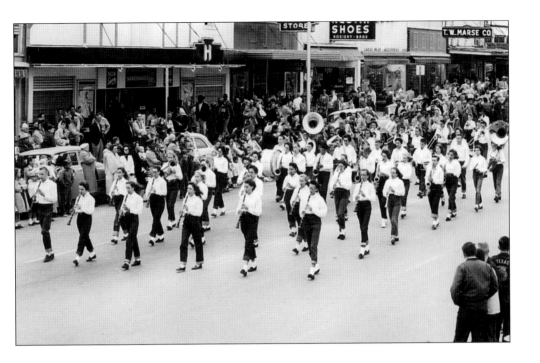

Here are two junior high school marching bands from Taylor. One is from O.L. Price, and the other is from Taylor Junior High. People stood just about everywhere to watch parades.

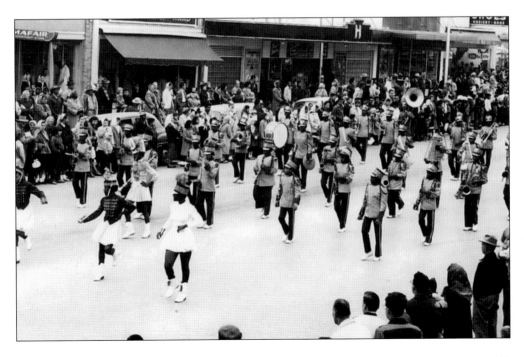

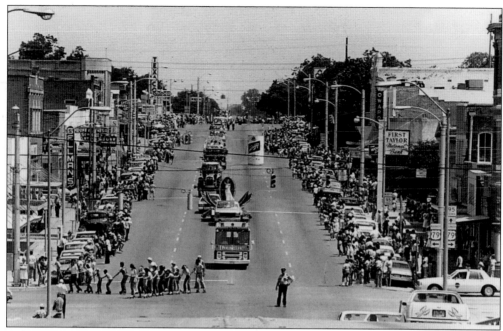

In later years, Taylor was still a popular place for parades. This is a rodeo parade with the 266th Army band, fire trucks, tractors, floats by the Taylor Chamber of Commerce, and young people skating down the street. The horses were the last part of the parade. The photograph was taken from the overpass at Second Street looking north.

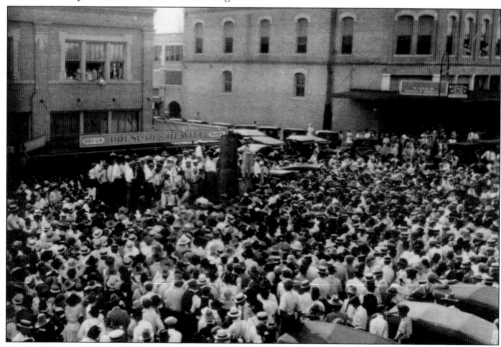

Trades Day on July 9, 1923, was held at the Preslar-Hewitt Building at 322 North Main Street. Trades Day was sponsored by the big stores and businesses in downtown Taylor. There were sales and entertainment to draw shoppers into town. This event has been going on for many years.

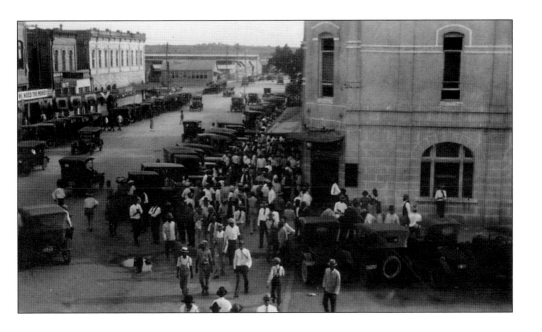

Preparations were underway for Dan Moody's 1924 campaign as governor of Texas. Plans were made to accommodate the hundreds and hundreds of people who planned to attend the event. People arrived early to make sure they would have a place to sit or stand close enough to see Moody.

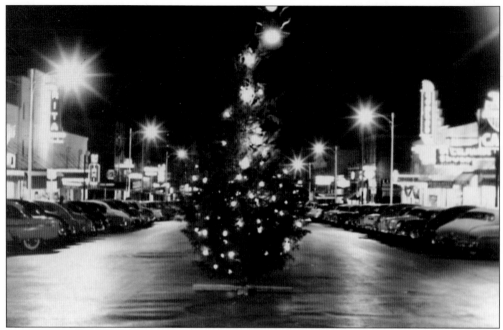

Christmastime in Taylor has always been very special. The town always decks out and has a parade with Santa Claus. Like many other towns, Taylor puts a Christmas tree on display for residents; however, unlike most towns, Taylor places the tree in a busy intersection. This is a special time for young and old.

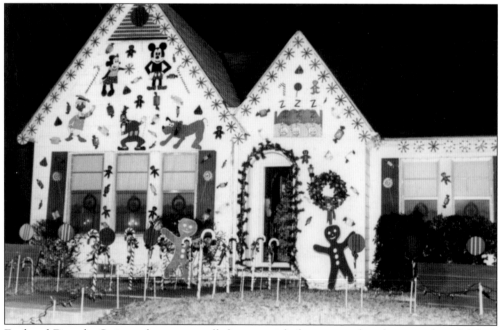

Fred and Dorothy Switzer always went all the way with decorating their home and yard. Their home, located on West Seventh Street, was always decorated as a ginger bread house with all of the Disney characters. It took quite a lot of work and time to get this ready, but it was always well worth it to have people come from all over just to see this special house.

Nine
WHEN COTTON WAS KING

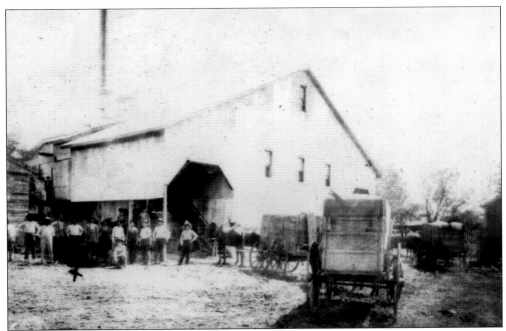

Taylor was known as the "King of Cotton." Cotton was the leading product, and Taylor became the largest inland cotton market in the world. At one time, there were 15–300 crews at work picking cotton, but it was estimated that 3,000 more workers were needed. Mechanical harvesting soon reduced the need for migratory workers. The first gin to be built in Taylor was in 1877 and was located on Second Street, where the Taylor Bedding plant is located now. On the corner of Seventh and Fowzer Streets was the Hartman Gin (pictured above), and the Kroschevsky Gin was located north of Taylor. (Courtesy of Jimmie Preuss.)

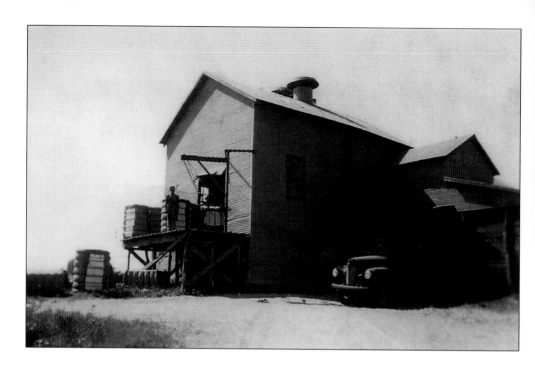

The Bachmayer Gin in Beyersville was built in 1931 after the original one burned in 1930. In 1954, the gin was destroyed by a tornado. It was rebuilt, and Ervin and Ralph Bachmayer ran this gin until a fire destroyed a part of the it. The gin closed, and Ervin's son Carroll Bachmayer now owns the building.

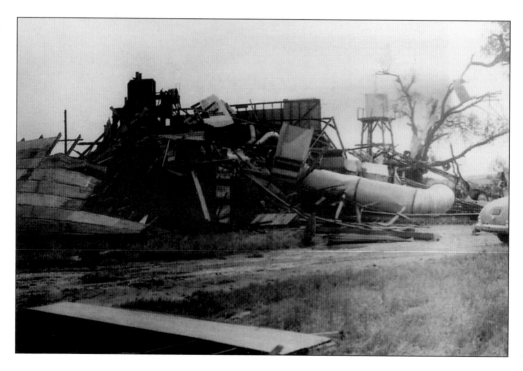

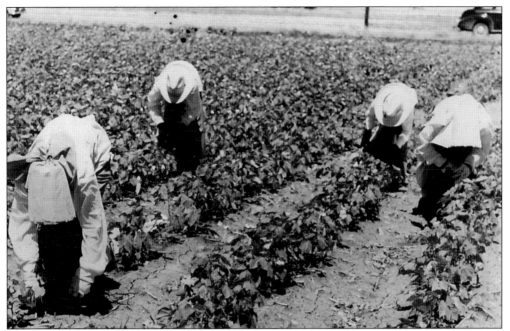

Cotton is being picked and put into sacks in 1954. Here, the cotton seems to be shorter than the cotton that is produced in today's market.

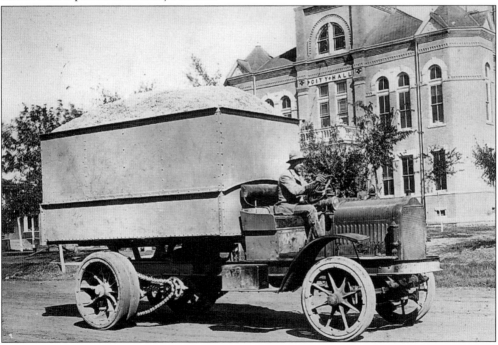

Shown in front of the 1905 city hall, R.J. Kroschewsky is hauling a load of cottonseed down Main Street. After the cotton is baled, the cottonseed is also sold. Many farmers buy the cottonseed to spread over their fields. The gin will also sell the cottonseed to cotton oil mills. The cottonseed oil mills process the seed to be sold for many purposes, including making shortening, cattle feed, and many other food items. (Courtesy of Carroll and Carol Bachmayer.)

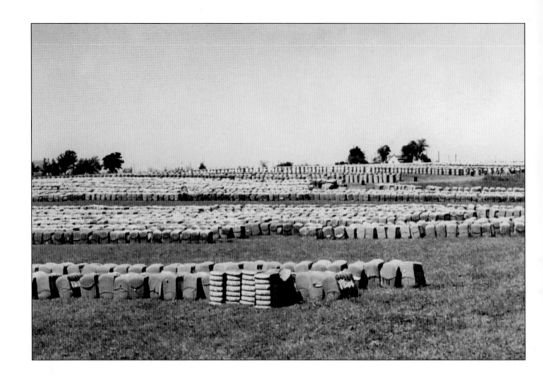

Cotton bales are spread out over the ground waiting to be picked up and delivered to the compress. In 1920, a truck with a load of cotton bales is ready to be taken to the Taylor Compress.

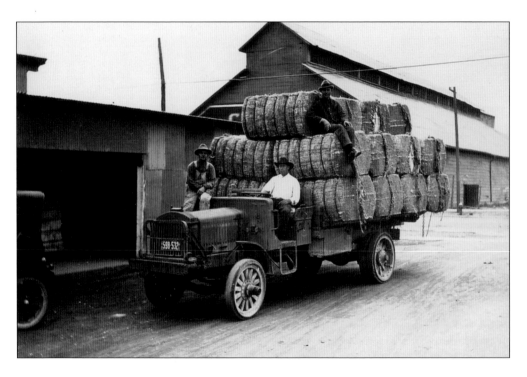

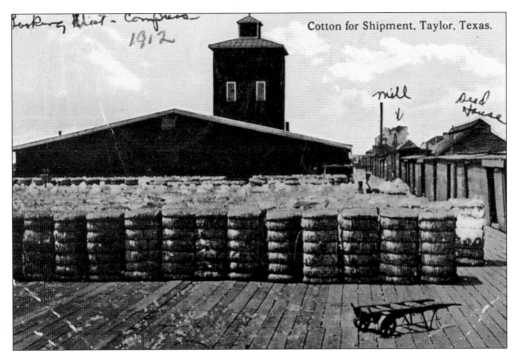

This postcard is of cotton waiting to be shipped from Taylor Compress in 1912. The compress was located near the railroad for easy shipping. There is also a mill and a seed house. The Taylor Compress is still located in Taylor.

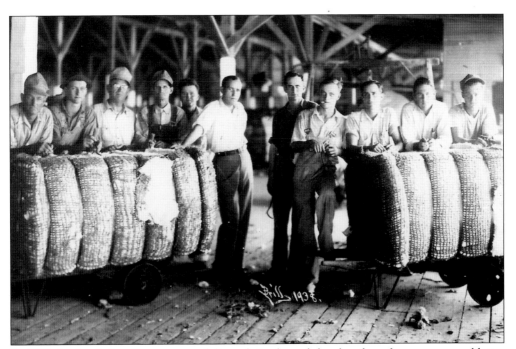

In 1938, the first bales of cotton were delivered. Banks and the chamber of commerce would give the farmer who brought in the first bale of cotton a small token for being first.

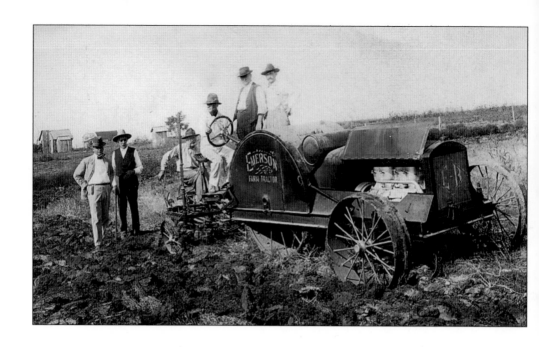

Here is a small group of men looking at the Emerson Farm Tractor with its plow. This was quite a sight to see one of the first tractors. Also, Edwin Bachmayer is shown raking hay in 1936. Bachmayer is driving a Farmall Tractor to do his work.

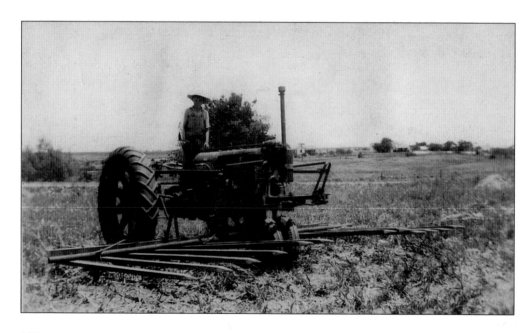

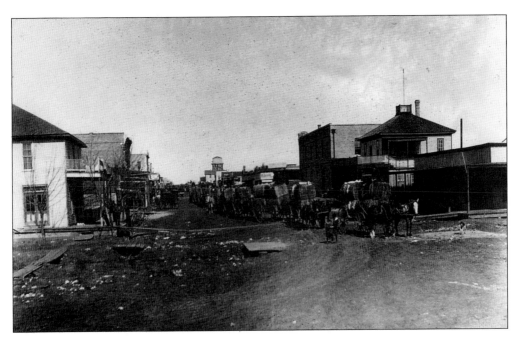

In the early 1880s, a horse-drawn trailer, loaded with cotton, was quite a sight to see traveling down Main Street. In 1889, wagons are seen at 203 North Main Street hauling cotton to the gin.

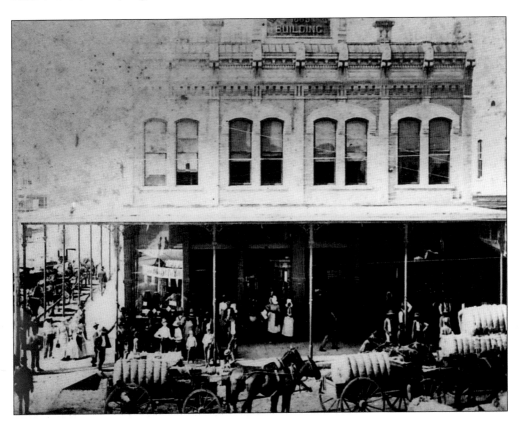

In the small community of Frame Switch, a small school was built and named the Yakey School. In 1903, there were 58 students. The community was the railroad flag stop. Lizzie Brunken, who attended Yakey School and was a 4-H Club member, won the clothing contest. She is shown wearing the dress made of cotton that gave her the win.

Ten

THRALL

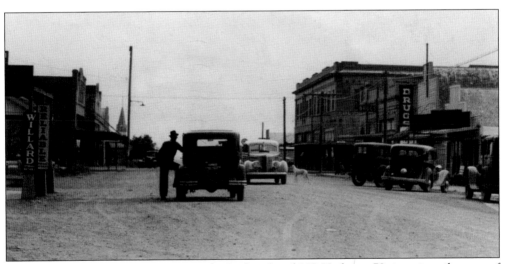

Thrall, Texas, is on the Missouri Pacific Railroad and US Highway 79, just six miles east of Taylor in eastern Williamson County. It was founded in 1876 as a railroad station that was first called Stiles Switch, which was after a family that owned a ranch at the site. The Stiles School was opened in the 1880s, and a gin was built in the 1890s. When a post office–general store was opened in 1901, the name Thrall was chosen for the community, after Homer S. Thrall, a Methodist minister and historian who was much admired by the Stiles family.

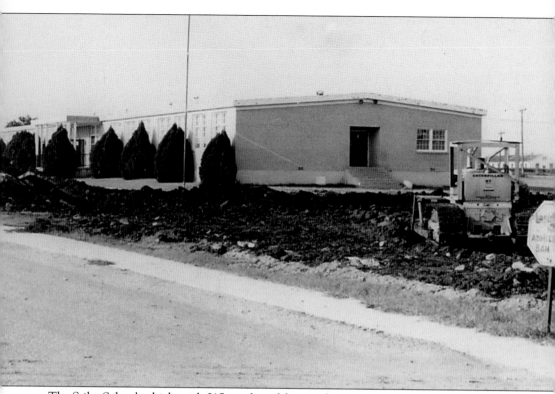

The Stiles School, which, with 215 pupils and five teachers in 1903, was the second-largest school in the county. The school moved to a larger building and renamed Thrall School in 1908. Today, Thrall has a very good school and has won many awards. The school also has a great athletic program. They have also added an elementary school. The town was a center for farming and cattle in the early years.

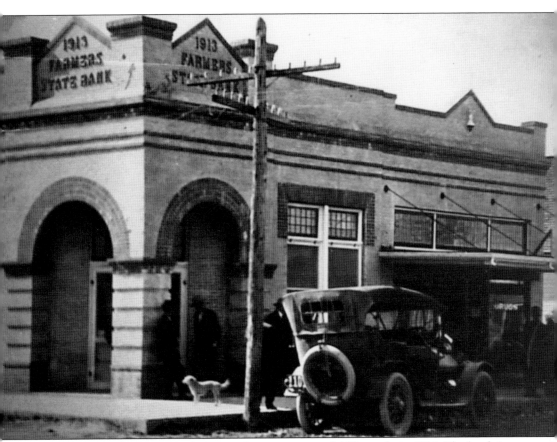

A bank that was built in 1913, and the population was a total 150 people in 1914. The bank is no longer there, and the businesses seem to have moved on. A small park has been added for the children to play. There are a few businesses and two convenience stores today.

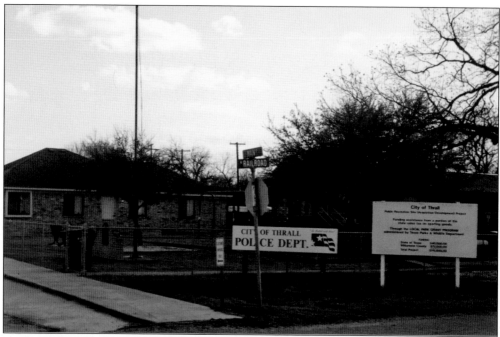

A new park is being built beside Thrall City Hall and Police Department. There are swings and slides for the young and benches for the older citizens to sit and visit with friends.

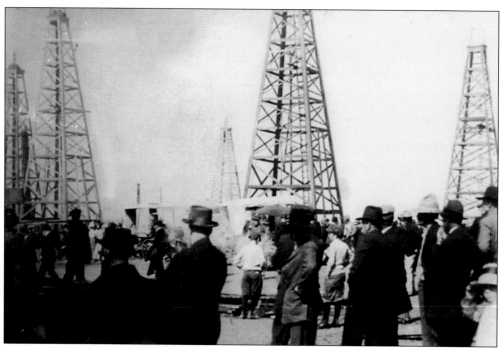

In 1915, Thrall was caught up in an economic boom resulting from the discovery of oil on nearby farms. Some 200 wells were dug in the area, and the population may have climbed as high as 3,000 over the next few years. But in 1920, the oil boom had leveled off and the population had fallen to 272. By 2000, the population had reached 710.

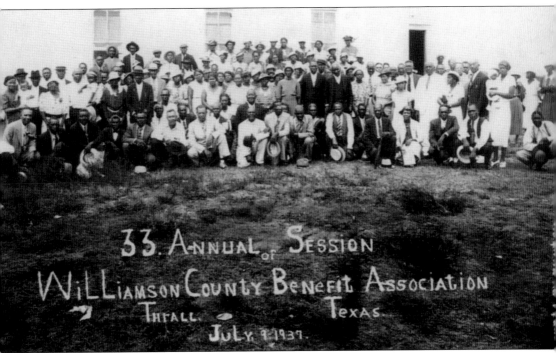

In July 9, 1937, the 33rd Annual Session of the Williamson County Benefit Association was held in Thrall.

www.arcadiapublishing.com

Discover books about the town where you grew up, the cities where your friends and families live, the town where your parents met, or even that retirement spot you've been dreaming about. Our Web site provides history lovers with exclusive deals, advanced notification about new titles, e-mail alerts of author events, and much more.

MADE IN THE USA

Arcadia Publishing, the leading local history publisher in the United States, is committed to making history accessible and meaningful through publishing books that celebrate and preserve the heritage of America's people and places. Consistent with our mission to preserve history on a local level, this book was printed in South Carolina on American-made paper and manufactured entirely in the United States.

This book carries the accredited Forest Stewardship Council (FSC) label and is printed on 100 percent FSC-certified paper. Products carrying the FSC label are independently certified to assure consumers that they come from forests that are managed to meet the social, economic, and ecological needs of present and future generations.

FSC
Mixed Sources
Product group from well-managed forests and other controlled sources

Cert no. SW-COC-001530
www.fsc.org
© 1996 Forest Stewardship Council

Find Your Place in History.